Anna Maria Wieland

Francis Bacon

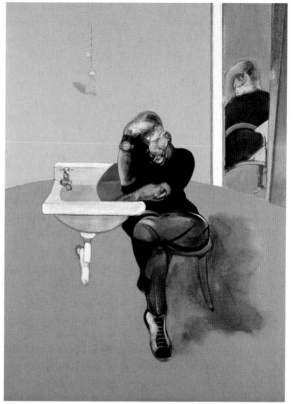

Prestel

Munich · Berlin · London · New York

Context

"But when you're outside a
tradition, as every artist is
 today, one can only want
 to record one's own
 feelings about certain
 situations as closely to
 one's own nervous system
 as one possibly can."

Francis Bacon

The Shifting World of Modernism

Modernism produced an abundance of art movements. In the midst of its many styles, Francis Bacon went his own way, though he took a constant interest in all creative happenings. He was interested in works by his contemporaries as well as the art of past masters.

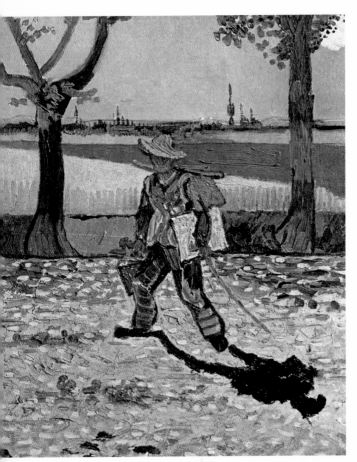

One of Bacon's early influences was Vincent van Gogh, whose works paved the way for Expressionism.

→ **Expressionism** is a style less concerned with the representation of a person, object or scene naturally than with the direct expression of an artist's emotions, little regard being paid to academic rules. The works of Vincent Van Gogh and Edward Munch show strong Expressionist tendencies, but strictly speaking the term is applied to a number of mostly German artists working before the First World War, including Ernst Ludwig Kircher (a member of the Die Brücke group), and Wassily Kandinsky and Franz Marc (both of whom were members of the group Der Blaue Reiter). Francis Bacon took considerable interest in Van Gogh's work and several times quotes his painting *The Artist on the Road to Tarascon* (1888, see illustration left, destroyed 1944), among others.

→ **Neue Sachlichkeit** was a post-First World War German art movement. Its cool and detached perspective was a reaction to the emotional nature of Expressionism. Neue Sachlichkeit painting is characterized by extreme, sometimes almost overdone realism. Verism, a movement within Neue Sachlichkeit, was often politically motivated, with undertones of strong social criticism. Major exponents of Neue Sachlichkeit include George Grosz and Otto Dix. The world of their

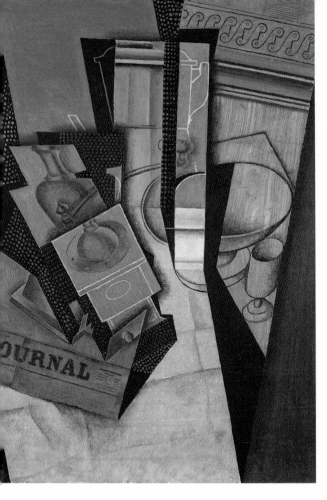

pressionist ideas in the USA and in Europe following the Second World War. In its expression of inner experiences and spontaneous emotions, it moved ever farther from objective representation. Its works were created using a free, gestural style, with no reference to any set of rules.

-→ **Action Painting** was a development of Abstract Expressionism. The form of a work was determined through gesture, i.e. by direct physical action on the part of the artist. The most prominent Action Painting artist was Jackson Pollock (photo below), who discovered the technique of drip painting, first used by Max Ernst, and made it his own. He threw or tipped or dripped pigment directly from the paint pot onto a canvas laid out on the floor. Other important exponents were Franz Kline and Robert

pictures records the Berlin of the 1920s that Bacon experienced during his stay there.

-→ **Cubism** began with the French Post-Impressionist Paul Cézanne. His faceted forms are echoed in the work of artists like George Braque, Pablo Picasso, and Juan Gris (see illustration above). At the beginning of the 20th century, these artists begin reducing their subjects to simple three-dimensional forms in muted colors, while combining different views of the same object on the painting surface. The visual style of Cubism, like that of Expressionism, became increasingly abstract.

-→ **Abstract Expressionism** was an art movement that took up and expanded Ex-

Motherwell. Bacon was consistently critical of abstract art, and in particular saw no point in Action Painting: "Action Painting is ... a form of decorative art. ... The only interesting thing about it is that if you splash a spot of paint down on the canvas, it is more interesting—because it has more vitality— than the inanities of academic art."

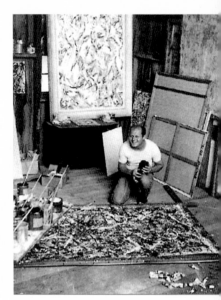

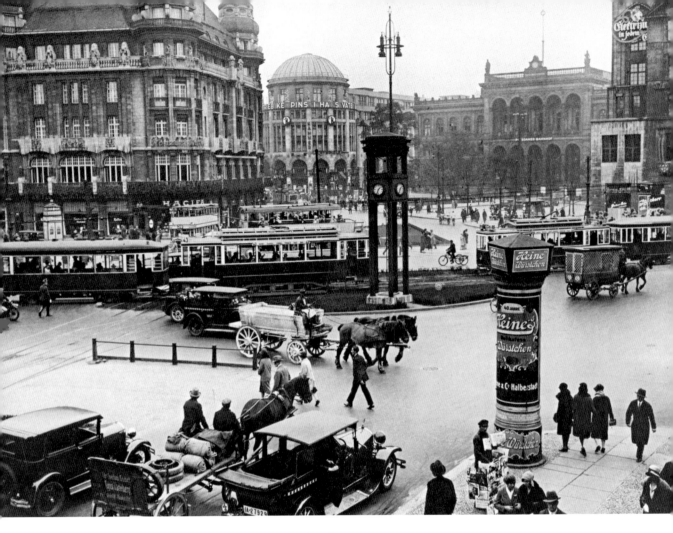

Francis Bacon experienced the Berlin of the Golden Twenties himself:
he had an extended stay in the German capital in spring 1927, and its
flourishing cultural life made a profound impression on him.

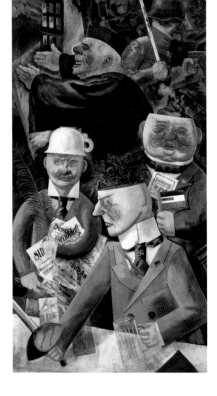

The work of the Berlin-born painter George Grosz presents revealing caricatures of his contemporaries. *Stützen der Gesellschaft* (Pillars of Society, 1926) is seen as one of his most important works.

A Time of Change

Europe in the early 20th century was a hotbed for experimental art styles. Everywhere a new dawn was being hailed as movements and trends proliferated. Expressionism and Futurism, Dada and Surrealism replaced Impressionism and Art Nouveau. Berlin, Munich, and Paris were all important centers.

The Golden Twenties

Francis Bacon was unaware of the artistic revolutions in mainland Europe during his childhood and youth, which were spent in Ireland and England. He got a first glimpse of the new energies seen in art everywhere in the years leading up to the Second World War when he visited Berlin as a young man. The capital of the Weimar Republic epitomized the "Golden Twenties" attitude to life. There were chic department stores, the first large cinemas, elegant theaters, and all kinds of smaller-scale performing arts: cabarets, ballrooms, cafés, bars, and nightclubs were the stage for all kinds of artistic expression.

"You see, painting has now become, or all art has now become completely a game, by which man distracts himself. What is fascinating actually is that it's going to become much more difficult for the artist, because he must really deepen the game to become any good at all."

Francis Bacon

The British artist Leon Kossoff, the son of Russian Jews, is part of the so-called School of London, to which Bacon is also allotted.

The atmosphere was electric, the excesses of the art community legendary.

Even if Bacon talked mainly about the glittering nightlife when remembering this period, we can assume that he also saw Neue Sachlichkeit paintings in Berlin. Artists like George Grosz and Otto Dix captured the mood of the time in their grotesque yet realistic pictures, in which they also overtly criticized social injustice and moral hypocrisy. In particular, Dix's often stark treatment of sex and violence may have made an impression on Bacon.

Pioneer of Modern Art

Pablo Picasso was a more obvious source of inspiration. When Bacon saw a Picasso exhibition for the first time, in the 1920s, the Spanish artist was already the undisputed international leader in modern art. Born in Malaga in 1881, Picasso broke with academic traditions from his youth onwards. His painting *Les Demoiselles d'Avignon* (1907, Museum of Modern Art, New York), a work that prepared the way for Cubism, created a sensation. Picasso's world of forms, his dismantling of bodies and objects into geometric elements, and his alienation of human contours were all an affront to public sensibilities. Bacon was one of those who remember their first encounters with Picasso's work as exceptionally intense.

New Order

The Second World War temporarily brought creative activity to a standstill in Europe. It also turned the USA into a centre of new impulses, as many European artists moved there. With exponents in both Europe and America, including Hans Hartung, Jackson Pollock, and Willem de Kooning, post-war Abstract Expressionism became an international phenomenon. Independent movements also arose

Frank Auerbach, another member of the School of London, was a friend of Bacon's, as was Lucian Freud.

in post-war Europe, such as Art Informel, which centered on Paris. In London, where Bacon was settled, artists like Graham Sutherland, whose paintings had Expressionist tendencies, and Henry Moore, who created almost abstract sculptures, became well established.

School of London

Bacon mixed with London art circles and knew Sutherland and Moore, but his work was independent and unaffected by contemporary trends. Despite the uniqueness of his works, Bacon is often considered part of the so-called School of London, along with the painters Lucian Freud, Leon Kossoff, Michael Andrews, and Frank Auerbach. These artists all evolved very different styles, ranging from Freud's realism to the expressive/abstract features of Auerbach's paintings. What they had in common was a clear commitment to painting as a medium (which sets them apart from new artistic avant-garde developments, such as Land Art and Conceptual Art), and an interest, shared by all five artists, in personal, individual expression. They were opposed to any form of didactic art, avoided moral undertones and political references, and did not see their work as part of any narrative tradition. Bacon and Freud, the most successful School of London artists, also shared a long-lasting friendship, one result being that they painted several portraits of each other.

London in the rain Frank Auerbach's *Camden Theatre in the Rain* dates from 1977. His style is very expressive, the paint is applied in thick, repeatedly worked layers. The Camden Theatre motif comes from Kossoff's immediate vicinity, his studio being in London's Camden Town, a district known for its mixed subcultures.

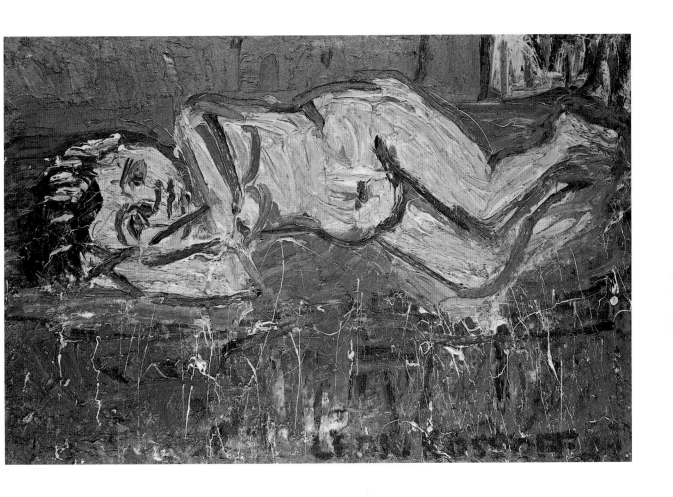

Faithfully figurative Leon Kossoff studied with Frank Auerbach under David Bomberg at the St Martin's School of Art in London. Like Auerbach, he also worked with thick layers of paint and expressive lines, and like him he kept faith with figurative painting despite abstract tendencies. *Nude on a Red Bed* dates from 1972.

Fame

"After all, to be
an artist at all is
a form of vanity."

Francis Bacon

"Look and let yourself be swept along…"

Francis Bacon was indiscreet both in his art and his personal life. He evoked ambivalent reactions, even long after the significance of his work for 20th-century art had been recognized. A selection of different voices, from art critics and art lovers to close associated makes this clear …

--→ **Paul Johnson**, journalist and art critic:
"He could not draw. His ability to paint was limited and the way he laid the pigments on the canvas was often barbarous. He had no ideas, other than one or two morbid fancies arising from his homosexuality, chaotic way of life, and Irish fear of death."

--→ **Lawrence Gowing**, artist and art historian, sometime deputy director of the Tate Gallery:
"In anticipation of a new work series [from Bacon] I begin to tremble a bit, can't contain my thoughts, can't sleep at night anymore. With every new painting, one can be assured that the finished piece will hit a central and sensitive nerve. … We don't need to judge or praise painting; it is enough to acknowledge that we wouldn't be able to get along without it."

--→ **Daniel Farson**, arts journalist and biographer of Bacon, friend of may years:
"I doubt if he was the greatest man I have known, but he was the most extraordinary. He was the most magical, and the most ruthless. He could not have been otherwise."

Michel Leiris

--→ **Michel Leiris**, French anthropologist, writer, leading figure on the French intellectual scene, friend of Bacon from 1965:
"… if he is judged by the unexpected originality of what he produced, he is a guerrilla who knows how to pay respect to those he thinks are great masters, but attaches himself to no school. … Faced with a painting by Francis Bacon you are bound to become as delighted and enthusiastic as reflective. Look and let yourself be swept along: that is exactly what you are required to do."

David Sylvester

-→ **David Sylvester**, British art critic and Bacon's travelling companion, recorded his numerous conversations with Bacon and later published them:

DS: Can I ask you an embarrassing question? Do you enjoy the kind of star quality which you have always had when moving among people?

FB: That's a thing that you are not conscious of yourself at all. I have no idea of what impression I make on other people.

DS: You have not been conscious that, when you come into a bar, you immediately become the centre of attention? That is something I have seen happen ever since I have known you, which means before you became famous as a painter, so it wasn't influenced by that.

FB: Perhaps I was drunk and garrulous, had a lot to say. I think that it can only be for that reason. No, I certainly am not conscious of those things; I really am not. This is not false modesty; I am just not conscious of it.

-→ **Lucian Freud**, British painter and long-standing friend of Bacon:

"I remember Francis Bacon would say that he felt he was giving art what he thought it previously lacked."

-→ **John Edwards**, Bacon's companion from 1974: "He loved the mornings, that's when he worked best, and even after very late nights of drinking that floored me—thirty years younger than him—he'd always be in the studio bright and early, painting."

-→ **Stephen Spender**, British writer and poet, and also a friend of Bacon:

"Even though Bacon's paintings do not provide us, in any respect, with solace in our day and age of concentration camps and hydrogen bombs, they also neither express an arrogant or a contemptible opinion of humanity. They are the work of a man of great humility, who sees his work as more of an examination than an achievement, who doesn't consider his own face more beautiful than the screaming faces of those he portraits, who sees in the commonality of suffering a reconciliation."

John Edwards

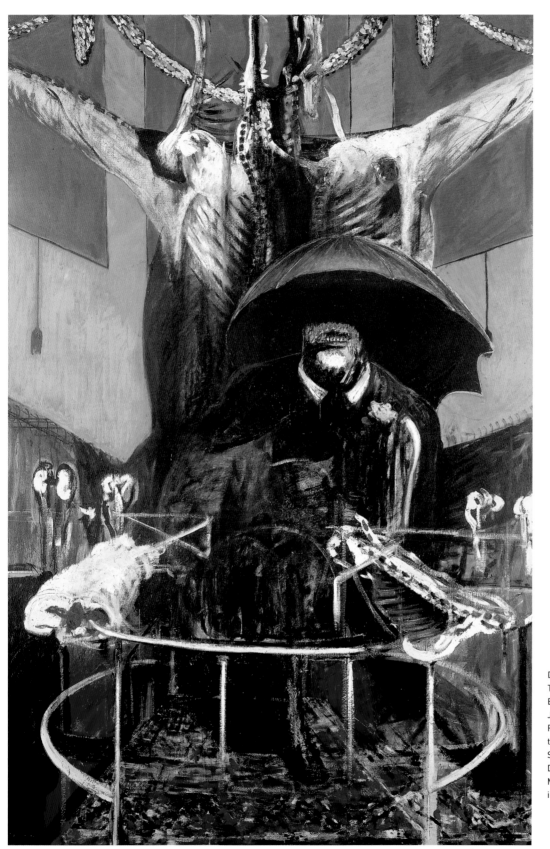

Der »gekreuzigte«
Tierkadaver in Francis
Bacons *Painting* aus dem
Jahr 1946 erinnert an
Rembrandts geschlach-
tete Ochsen und Chaim
Soutines Rinderhälften.
Das Werk wird 1948 vom
Museum of Modern Art
in New York gekauft.

Gallery owner Erica Brausen represented Bacon for 12 years and was significant in securing his reputation.

"The greatest living painter"

Despite the barrage of devastating criticism that Francis Bacon suffered during his first years as an artist, he achieved something very few artists of his generation achieved: he was celebrated in several retrospectives within his own lifetime, and sales of his work made him wealthy and secure.

A Difficult Start

Bacon, a self-proclaimed "late starter," first participated in group exhibitions in the 1930s, and even organized his own solo exhibition. Although some positive responses are on record, and the collector Sir Michael Sadler bought one of his paintings, Bacon was deluged with overwhelmingly negative verdicts. Starting with "childish composition" and a "mere unloading on canvas and paper," the damning reviews culminate with the *Daily Mail* critic Pierre-Jeannerat's statement: "Nonsense Art invades London. ... The more we see of such absurdities the

> "I have left my mark; my work is hung in museums, but maybe one day the Tate Gallery or the other museums will banish me to the cellar ... you never know."
>
> **Francis Bacon**

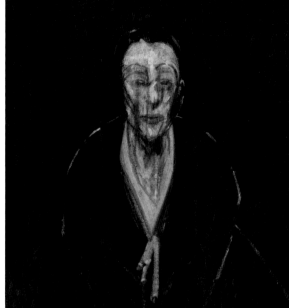

Art patrons Robert and Lisa Sainsbury started to acquire works by Bacon in the 1950s. The couple founded the Sainsbury Centre for the Visual Arts at the University of East Anglia in Norwich in 1978, and their collection can be seen there today.

more we shall realize their emptiness and ugliness." The backlash affected Bacon deeply and, always self-critical, he destroyed most of his works; only about 15 works painted between 1929 and 1944 survive.

The Road to Success

Everything changed in 1944 with the triptych *Three Studies for Figures at the Base of a Crucifixion*, which he painted at a time when his direction as an artist had become clearer to him. At its first public showing, this work was also largely rejected, but Bacon was now no longer so sensitive to criticism. More group exhibitions follow, and in 1946 he attracted the attention of Erica Brausen, who worked for the Hanover Gallery in London. Later she became his agent, standing by him with unshakable faith and supporting him financially when, as often happened during this period, he needed money. Her first great coup was the sale of his work *Painting* to the Museum of Modern Art in New York in 1948. In 1949, with Bacon's first appearance in a

Hanover Gallery exhibition, the reviews were not all positive, but neither were they as overwhelmingly negative as in the early years. Several more exhibitions followed, steadily increasing his reputation. He also attracted private patrons and supporters without the help of Brausen and the Hanover Gallery, including Lisa and Robert Sainsbury, who bought some of his works and even had their portraits painted by him.

Success

In 1954, Bacon, together with Lucian Freud and Ben Nicholson, represented Great Britain at the Venice Biennale. Alain Jouffroy, writing on Bacon for the Paris journal *Arts*, observed: "This work, a terrible vision of present-day humanity, is without doubt the only true discovery of the entire Biennale." In 1958, Bacon decided to leave the Hanover Gallery and move to the famous Marlborough Fine Art Gallery. He told Brausen that this was due to financial problems, but the real reason may have been the Marlborough

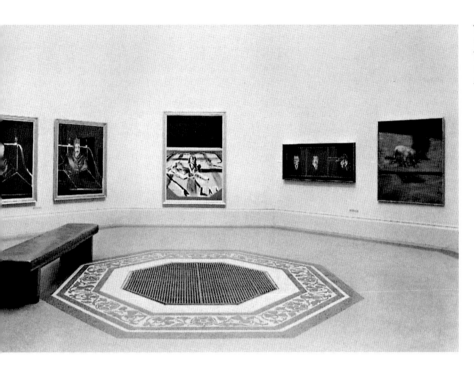

View of an exhibition gallery at the Francis Bacon retrospective in the Tate Gallery, London, which opened in May 1962. The *Times* exhibition review alluded to its "emotional shock."

Gallery's reputation. Frank Lloyd and Henry Fisher, the founders of Marlborough, and Valerie Beston, an employee, worked hard to make Bacon internationally famous, leading to a steady increase in appreciation for his work after he joined them. All three played a pivotal role in preparing for his greatest triumph yet: a retrospective of his works in the Tate Gallery, which opened in May 1962. This exhibition of 92 works was a great success. Among the most important paintings was the triptych *Three Studies for a Crucifixion*, which Bacon completed only just in time and which was still wet when delivered to the Tate. The exhibition toured Mannheim, Turin, Zurich, and Amsterdam. In 1963, the Guggenheim Museum in New York organized a further retrospective with 65 works.

Art's Hall of Fame

After these retrospectives, if not before, Bacon became well established in the art world. He became friends with artists like Alberto Giacometti and the American photographer Peter Beard, and the art critic David Sylvester and the author Michel Leiris became his confidants; both of them later published their conversations with him. Bacon also kept in contact with Lucian Freud, though the painters Roy de Maistre and Graham Sutherland, once his closest associates, increasingly distanced themselves from him.

Bacon's love of Paris, where his work had been regularly shown in galleries since 1957, was confirmed when the greatest retrospective of his work to date was staged at the Grand Palais in 1971. The 108

Photographer Peter Beard and Francis Bacon were close friends. Their high esteem for each other is also documented in mutual portraits.

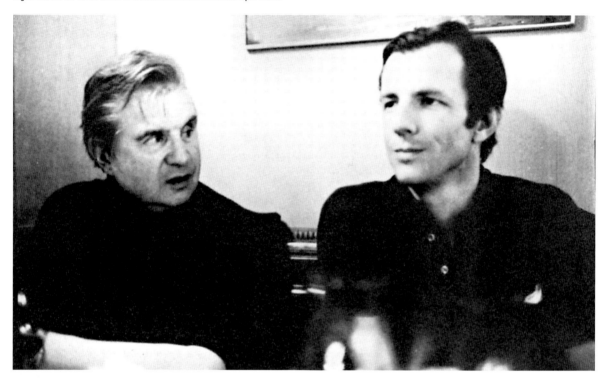

pictures attracted huge crowds. The literary magazine *La Quinzaine Littéraire* was caught up in the enthusiasm: "One should really visit the Grand Palais where this large retrospective confronts us with a unique oeuvre." Bacon appeared at the top of a list of the ten most important living artists in the French magazine *Connaissances des Arts* (with Pablo Picasso excluded). In 1974, even the Metropolitan Museum in New York dedicated an exhibition to him, the first of a contemporary British artist in the museum's history. In 1977, when the Galerie Claude Bernard in Paris presented new paintings by Bacon, the police had to intervene to control the crowd. Bacon was continued to be honored in exhibitions and reviews. In the Tate Gallery,

where the director Alan Bowness considered Bacon "surely the greatest living painter," there was even a second large retrospective in 1985. Another highlight in Bacon's career was the Moscow exhibition in 1988, arranged by London gallery owner James Birch in collaboration with a Soviet diplomat. During the Cold War, this was a minor sensation: never before had the work of such an important living Western artist been shown behind the Iron Curtain on this scale.

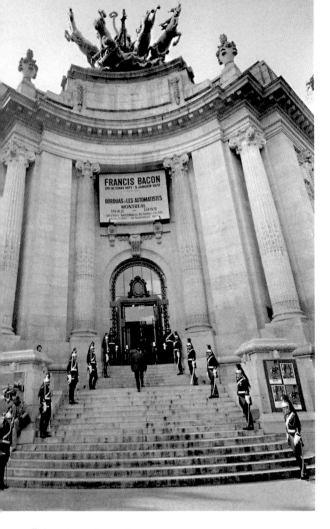

left: the Republican Guard provided a guard of honor on 26th October 1971, the morning the *Francis Bacon* exhibition opened. A total of 108 pictures, including three triptychs, were shown.

below: The public came in droves when Bacon's work was shown in the Central House of Artists in Moscow in 1988.

"Not that dreadful man ..."

When Bacon died in Madrid on 28 April 1992, his death was mourned worldwide. Bacon himself once told Peter Beard that the most exciting thing about being an artist was that you would never know if your own work is really good because of the time and distance needed to really know the true worth of a work. And yet he received in his own lifetime what is denied many artists: recognition and wealth. However, his success never went to his head, and he had no use for many aspects of fame. He rejected prizes and accolades offered to him, including the Order of Merit, a knighthood, and membership of the Royal Academy. The only prize he did accept was the city of Siegen's Rubens Prize, only to donate the money immediately to the restoration of Florence's artworks. He never took himself too seriously, and reacted to insults with humor. One of his favorite incidents relates to the British Prime Minister, Margaret Thatcher. When she asked the Tate's director whom he considered the greatest living British painter, and was told Bacon, she replied: "Not that dreadful man who paints those horrible pictures!"

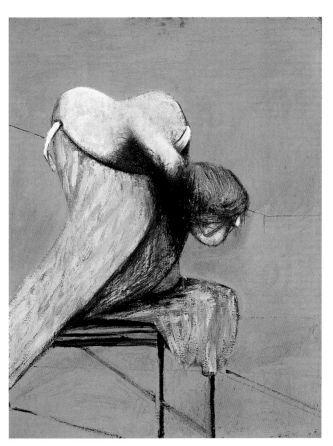
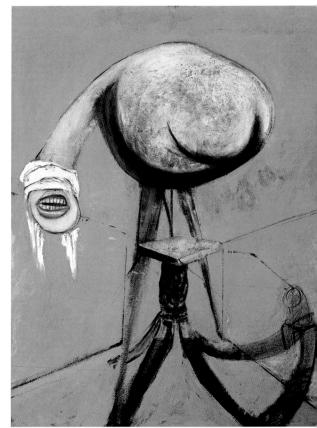

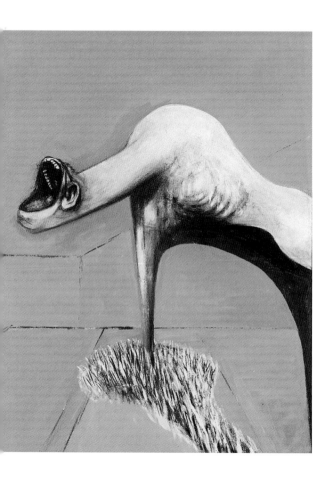

Goddesses of revenge The three figures in the 1944 *Three Studies for Figures at the Base of a Crucifixion* were inspired by the Furies (Erinyes) from the *Oresteia* by Aeschylus. Art critic John Russell describes his impressions: "Each one seemed cornered, waiting to pull the viewer down to them ... they caused utter consternation."

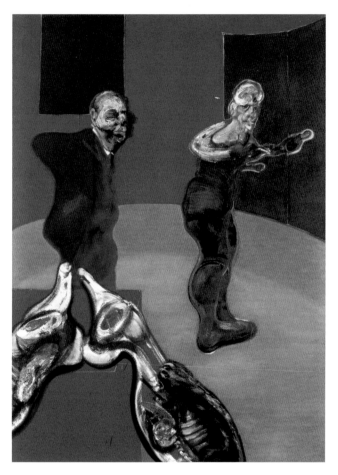

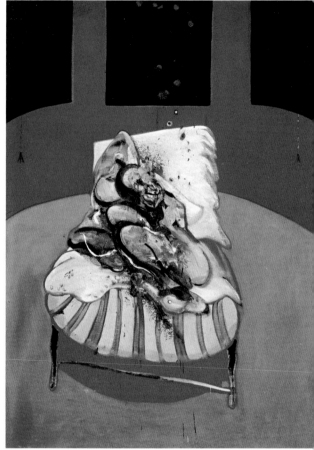

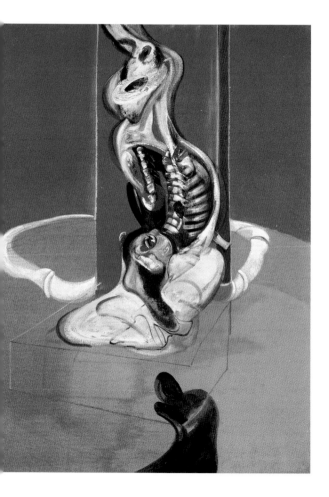

Tormented flesh Bacon painted *Three Studies for a Crucifixion* in 1962 with his eye on the forthcoming exhibition in the Tate Gallery. It was the first triptych since his epoch-making *Three Studies for Figures at the Base of a Crucifixion* and is seen as one of his most brutal and distressing, but also one of his most important. He himself said that he always wanted to make "things that are really formal yet coming to bits."

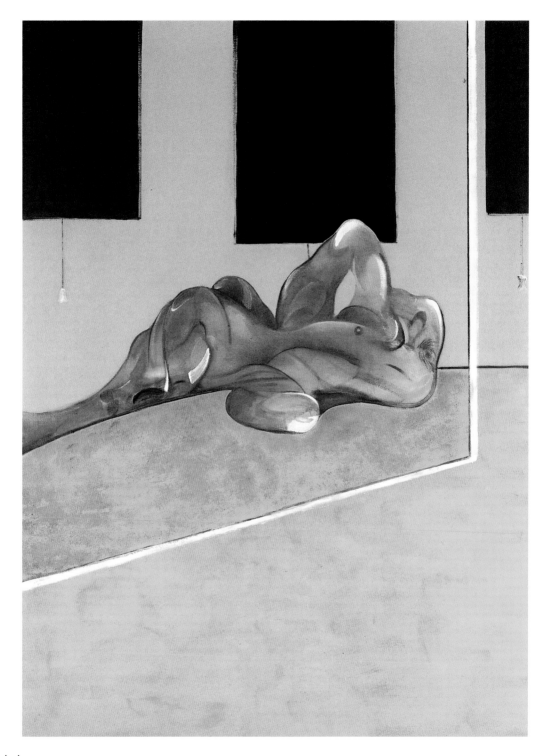

Body language Bacon's *Lying Figure in a Mirror* dating from 1971 admits various associations, starting with Picasso's dissection of human bodies via the soft formal language of the sculptor Henry Moore to Michelangelo's figures on the Medici tomb and the sculptures of his contemporary Helen Lessore.

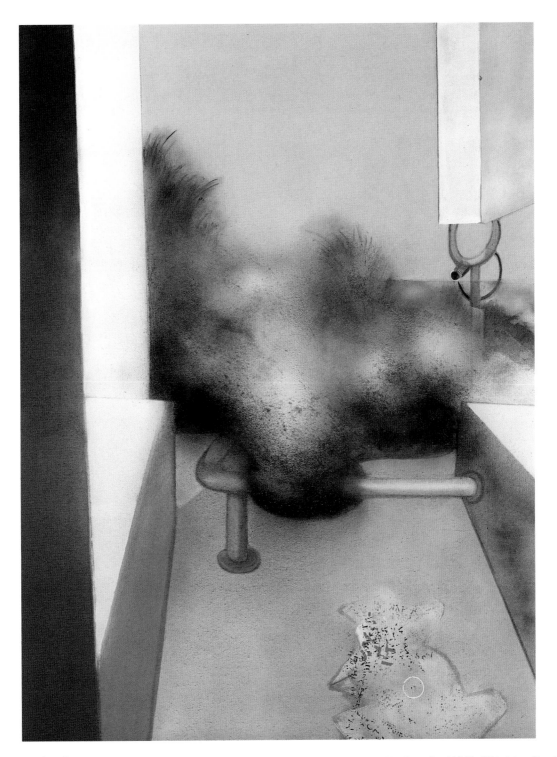

Unnatural nature Bacon's ambition was to "take all the naturalism out" of his landscapes. The frame in which his 1981 picture *Dune* is embedded is appropriately technoid and industrial. In contrast with this anti-naturalism, the graininess of the sand is emphasized by adding dust to the paint.

Art

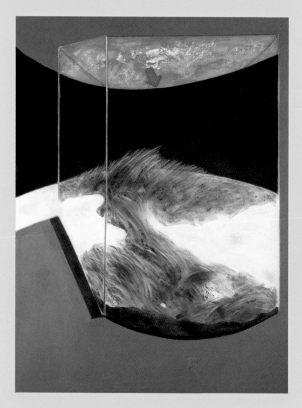

"What I want to do
is to distort the
thing far beyond
the appearance,
but in the distortion
to bring it back to
a recording of the
appearance."

Francis Bacon

From Aeschylus to Muybridge

Bacon's complex influences indicate his wide-ranging interests. Literature, poetry, photography and art: he acquired comprehensive knowledge in all spheres, and drew an abundance of thoughts, ideas, and images from them that then affected his work more or less directly.

Painting and Poetry

In his conversations, Bacon mentioned the powerful impact that T.S. Eliot's poetry had on his work. Born in St Louis (Missouri) in 1888, the poet and dramatist moved to England in 1914 and became a British subject in 1927. He won the Nobel Prize in 1948 and was one of the most important figures in the emergence of literary Modernism. His writings were influenced by the tradition of wisdom literature, from ancient Greek philosophy to Buddhism and Christian mysticism; a committed Christian, he was concerned with such subjects as the nature of the spirit, time, and eternity. Bacon first got to know Eliot's work at a performance of his play *The Family Reunion* in London in 1939, and studied his writings closely from then on. After Bacon's death, several books as well as notes with short references to poems by Eliot were found in his home and his studio. There are also clear references to Eliot's work in some details or picture titles: for example, the title of *A Piece of Waste Land*, painted in 1982, refers to Eliot's poem *The Waste Land*, published in 1922.

T.S. Eliot

In Thrall to the Furies

Bacon mentions the tragic trilogy the *Oresteia* by the Ancient Greek dramatist Aeschylus in connection with his first, groundbreaking triptych *Three Studies for Figures at the Base of a Crucifixion*, painted in 1944 The goddesses of revenge (the Furies, or Erinyes), who play a key part in the Oresteia, took a firm hold on his mind. Bacon owned a copy of the book Aeschylus in His Style: *A Study in Language and Personality* (1942) by W.B. Stanford, which contains faithful translations of the play. These texts, in their new English versions, seem to have had a profound influence on Bacon. He frequently quoted a stark line that particularly appealed to him when the Furies were being discussed: "The stench of human blood is joy for my heart."

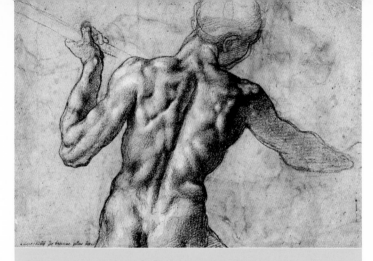

Traces of Old Masters

Bacon acquired a sound knowledge of art history in his life-time, as eloquently evidenced by the numerous illustrated volumes, monographs, and individual reproductions in his studio. He had more books about Michelangelo, whose writings and drawings he valued highly, than about any other artist. He was also very interested in the Spanish artist Diego Velázquez: Bacon owned numerous reproductions of his *Portrait of Pope Innocent X*, which played a major part in his own work. Other artists on whom he collected material included Rembrandt van Rijn—Bacon was particularly impressed by his numerous self-portraits—and Vincent Van Gogh, to whom he also relates in his work.

Rigidity and Movement

One important source of inspiration for Bacon was the British photographer Eadweard Muybridge, who was a pioneer of photographic technique. He worked first of all as a landscape photographer, then established serial photography in 1832 with a sequence of shots of a galloping horse, proving for the first time that the animal can have all four legs in the air at the same time. The photographer created his serial shots by releasing the shutters of several cameras successively, thus recording sequences of movement in human beings and animals in minute detail. He published his photographs in two volumes, *Animals in Locomotion* and *The Human Figure in Motion*, in Philadelphia in 1887. Bacon was fascinated not just by Muybridge's comprehensive body studies, but also by his obvious taste for unusual subjects, seen in series such as *Chicken Scared by a Torpedo* or *Man Walking after Traumatism of the Head*.

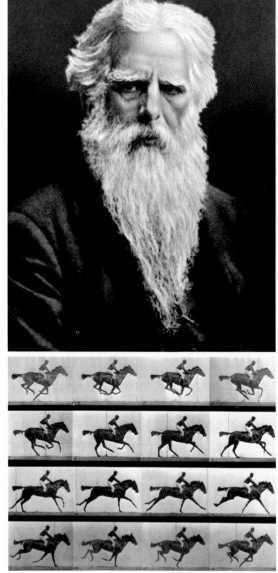

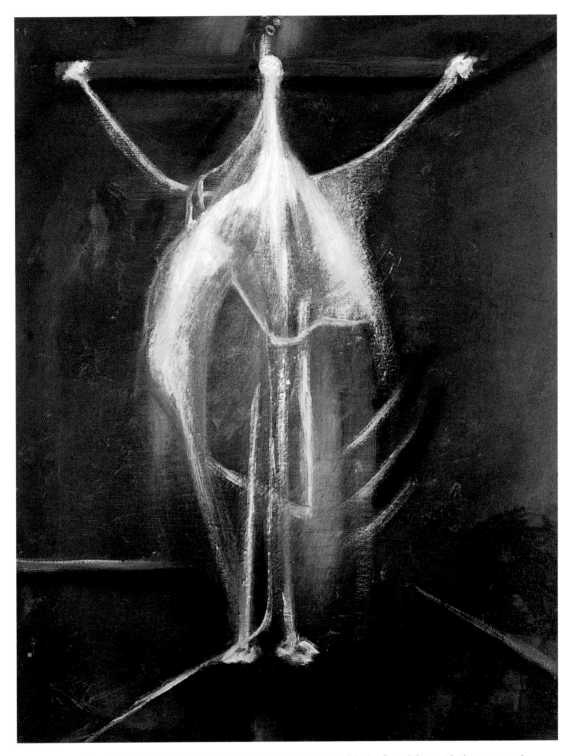

Bacon's 1933 *Crucifixion* looks like an X-ray photograph. It is possible that Bacon's interest in the paranormal phenomenon of ectoplasm is also evident here: there were photographs in his studio of people with a grayish-white foamy substance emerging from their bodily orifices.

Francis Bacon in his studio, photographed by Douglas Glass in 1960.

The Incomprehensible Human Being

Francis Bacon's work was unique in 20th-century art. It belonged to no movement or trend, and yet it left traces in modern art that are impossible to ignore. His artistic obsession was to find ways of expressing what could not be communicated in words.

The Search for Reality

Bacon was dedicated to representation; he showed no interest in the abstract art that caused an international furor in the 1950s and 1960s, even condemning some examples of it. But his urge to represent appearances went beyond depicting mere reality. He was concerned with underlying layers of feeling, metaphysical structures, and the complex many-layered nature of what we call "life." The brutality and rawness of his pictures, their distortions and alienations, express Bacon's own, very

> "Hardly anyone really feels about painting: they read things into it—even the most intelligent people— they think they understand it, but very, very few people are aesthetically touched by painting."
>
> **Francis Bacon**

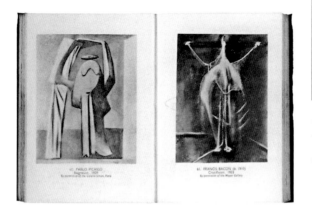

left: When a picture by Bacon, who was completely unknown at the time, appeared in the book *Art Now* by the respected writer and art historian Herbert Read, on a double page next to a *Woman Bathing* by Picasso, it was like being knighted.

subtle perception of his models and subjects—and of existence itself. He described his work as the attempt "to make the construction by which this thing will be caught raw and alive and left there and, you may say, finally fossilized."

Influential Encounters

Bacon had no regular education. He did not attend an art school, and art played no part in his childhood and youth. When he left his family in Ireland at the age of 16, he had no career in mind. During a long stay in Paris, however, he saw an exhibition of drawings by Pablo Picasso in the Paul Rosenberg Gallery that made a lasting impression on him: "I experienced a jolt that gave me the urge to become a painter." Picasso was not the only artist who awakened his interest in art; spending a few months with a family in Chantilly to learn French, he often went to the Musée Condé to see a single painting, Nicolas Poussin's *The Massacre of the Innocents* (1628–29). What fascinated him was the

depiction of a despairing mother, and he pointed to it years later as the best rendering of a human scream.

First Steps

Despite these crucial experiences, Bacon had no desire to train as an artist. He didn't see the point of art schools, considering them backward and meaningless, and initially he was not all that keen to teach himself. He settled in London, and looking back at these first few years he later admitted that he had spent more time amusing himself than painting. For a short time he worked as a designer, designing furniture and carpets that look like both contemporary French and Bauhaus design. His work found favor, but Bacon himself was never satisfied with it, sensing its lack of creative independence. At last, at 23 years of age, he painted a work that today is considered the beginning of the important part of his career, *Crucifixion*, which shows, against a dark space, a ghostly apparition whose

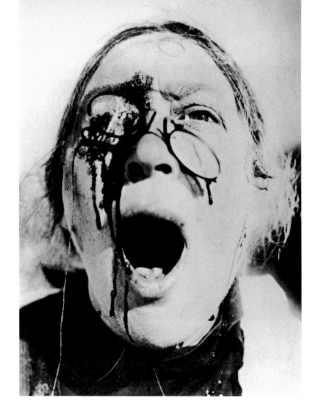

The enlarged still of the dying nursemaid from Sergei Eisenstein's classic silent film *Battleship Potemkin* provided one of Bacon's models for his work. The expression in this "silent scream" can be found, for example, in some of his pope paintings.

tiny head touches the upper edge of the picture (page 34). This work and others by him even appeared in two group exhibitions at the Major Gallery in London. However, the work achieved its greatest recognition through its inclusion in the book *Art Now: An Introduction to the Theory of Modern Painting and Sculpture* by the celebrated art critic Herbert Read. Read placed it on one page of a two-page spread opposite Picasso's *Female Bather with Raised Arms* (1929, Phoenix Art Museum), the aim being to illustrate how Picasso's biomorphic shapes of the 1920s had influenced Bacon's artistic development in terms of form. It was some years before Bacon reappeared in the public eye as an artist. Although he later claimed that he regretted having lived for the day instead of being artistically productive during this time, some of those who were there, such as a former lodger, claim that he was in fact very productive. However, most of the works produced during this period no longer exist, for Bacon, dissatisfied, destroyed them.

The Scream

In 1944, Bacon completed a triptych he had been working on for a long time: *Three Studies for Figures at the Base of a Crucifixion* (pages 24-25). In the following year, when the work was shown together with other works by Bacon at an exhibition at the London Lefevre Gallery, the public and even critics were shocked. The critic John Russell described Bacon's painting as "so unrelievedly awful ... that the mind shut with a snap." Even if Russell's comment was not necessarily meant positively, this is precisely the reaction that Bacon wanted his work to have: a direct impact on something deep within the viewer, a comprehension that bypasses the intellect. Each of the crude, long-necked beings of *Three Studies for Figures at the Base of a Crucifixion,* which are placed in front of an alarming orange background, expresses through its gesture an incomprehensible oppression, culminating in the screaming mouth in the right-hand panel. Bacon later explained that, despite the reference to crucifixion in the title, his iconography was based on the Furies (Erinyes) from

Bacon produced several variations on this portrait of *Pope Innocent X* by Diego Velázquez dating from 1650.

the *Oresteia* trilogy by the Greek tragedian Aeschylus. The screaming figure is also typical of Bacon's interest—bordering on obsession—with the human mouth, and with the scream as an expression of despair. As well as Poussin's screaming mother, an image from Sergei Eisenstein's silent film *Battleship Potemkin*, which he saw for the first time in 1935, became the archetypal expression of pain for him. When the nurse on the harbor steps of Odessa is shot, the camera focuses frontally on her face: the spectacles smashed by the bullet, the blood flowing down her right cheek, and the open, screaming mouth. There exists one Bacon picture with an explicit connection to the nurse—*Study for the Nurse in the Film "Battleship Potemkin"*—but the echo of her scream can be seen in other works by Bacon, for instance in the many images of popes that he worked on mainly in the late 1940s and early 1950s.

The Popes

The pope as a motif in Bacon's work came from his interest in *Portrait of Pope Innocent X* (c. 1650,

Doria Pamphilj Gallery, Rome) by the Spanish artist Diego Velázquez (1599–1660). For him this was one of the most important paintings in the history of art, not least because of its intense colors. He first referred to Velázquez' *Innocent X* in *Head VI*, which he painted in 1949 (page 40). The figure, enclosed in the outline of a cube, is reduced to the head and shoulders. Everything centers on the scream. "I have always been very moved by the movements of the mouth and the shape of the mouth and the teeth. People say that these have all sorts of sexual implications ... I like, you may say, the glitter and color that comes from the mouth ..." Bacon gave form as the reason why he was so intensively concerned with the picture of the pope. He rejected the claim by his long-time confidant David Sylvester, and

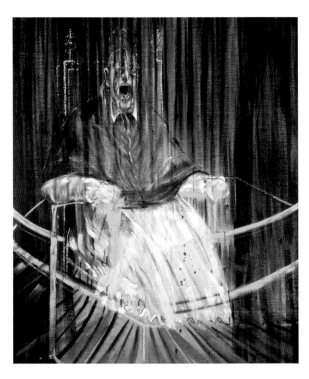

others, that it was unconsciously linked with his own difficult relationship with his father—the pope as "il papa"—though he did add that it is difficult to know where an *idée fixe* comes from. Later, he was not pleased with the art created by this pope fixation, even calling it foolish and criticizing his attempts to capture a scream: "I did hope at one time to make—it hasn't got any special psychological significance—I did hope one day to make the best painting of the human cry. I was not able to do it and it's much better in the Eisenstein and there it is."

Photography's Role

Bacon owned a huge fund of prints, publications, and reproductions, some of which inspired him directly or indirectly. His studio at 7 Reece Mews in London—where books, torn-out pages, copies, postcards, and notes together with his working materials created a bizarre chaos—looked like his inner world of associated unconnected elements, images and impulses made solid (see Bacon Today, page 12). Bacon himself credited photography with an important role in his work: "Because I am moved by photographic depiction, I begin to move into the picture, and begin to decipher what I consider to be its truth better than I could by directly looking at the reality. Often photographs are not only points of reference, but the trigger for ideas." Bacon was particularly influenced by one of the pioneers of photography, Eadweard Muybridge (1830–1904), whose studies of human and animal movement attracted the attention of the worlds of science and art in equal degrees during the 19th century. Muybridge's series showing movement sequences have many echoes in Bacon's work. Bacon's images of couples are a striking quotation from Muybridge—for instance the two works from the

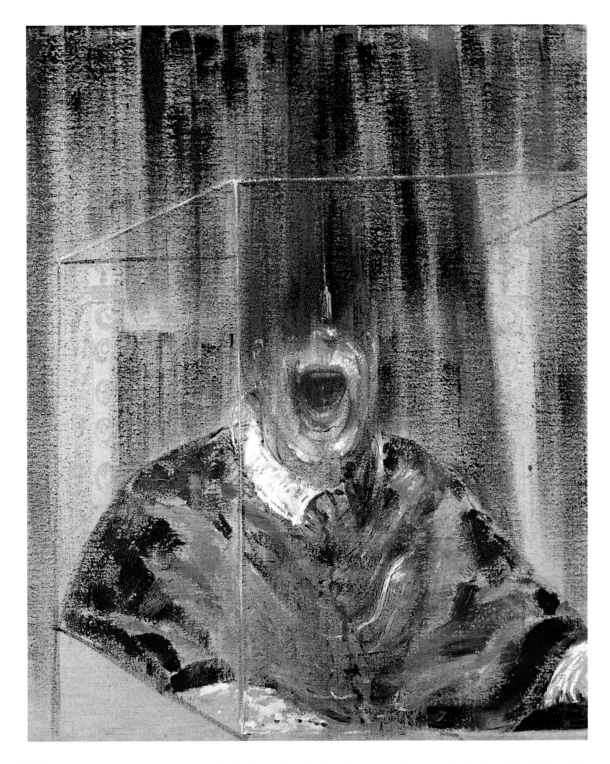

Nightmare The figure in Bacon's 1949 painting *Head VI* sits in isolation in a box-like structure, the canvas showing through the lightly applied background paint. The man's robes make a link with Diego Velázquez's portrait of the pope. The mouth open to scream that forms the centre of the composition dominates the face, which is not completely developed. The lack of any context creates an even greater feeling of unease.

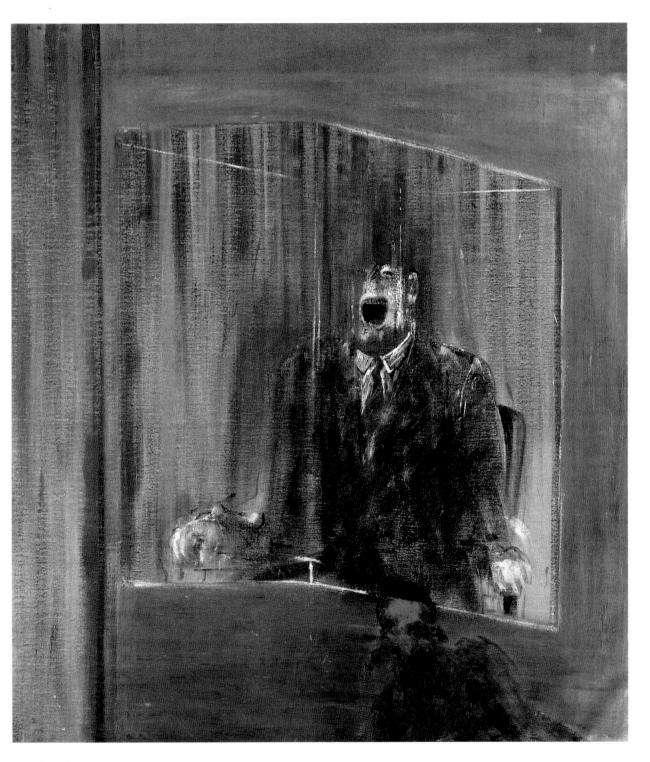

Glass boxes When talking about the boxes in which Bacon frequently "shuts up" his figures, the trial of SS-Obersturmbandführer Adolf Eichmann is regularly invoked. Eichmann sat in a glass cage during the proceedings, which took place in Israel in 1961. But in fact Bacon used his vision of a "cage" considerably earlier, as shown for example in works such as *Head VI* and *Study for a Portrait*, both painted in 1949.

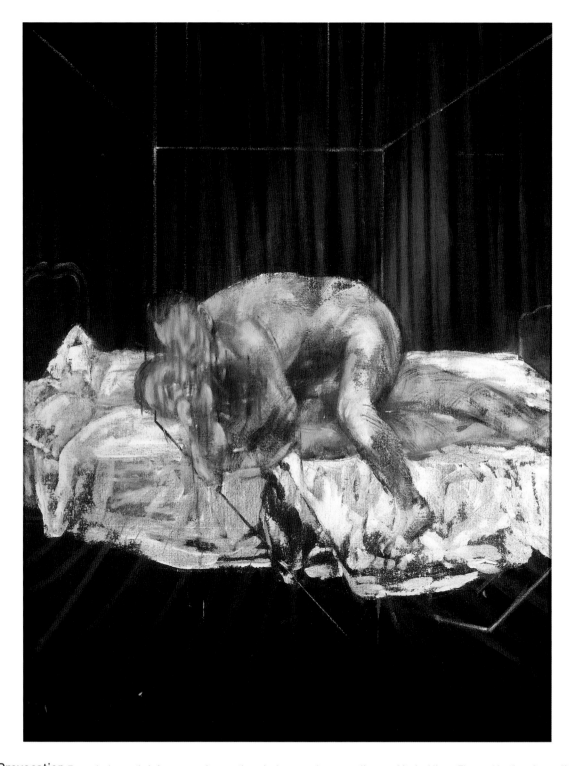

Provocation Two naked men, their faces scarcely more than shadowy smudges, wrestling on white bed linen. The combination of sexuality and violence, of physical proximity and simultaneous brutality, set in a dark room, meant that *Two Figures* of 1953 was not shown in public for many years.

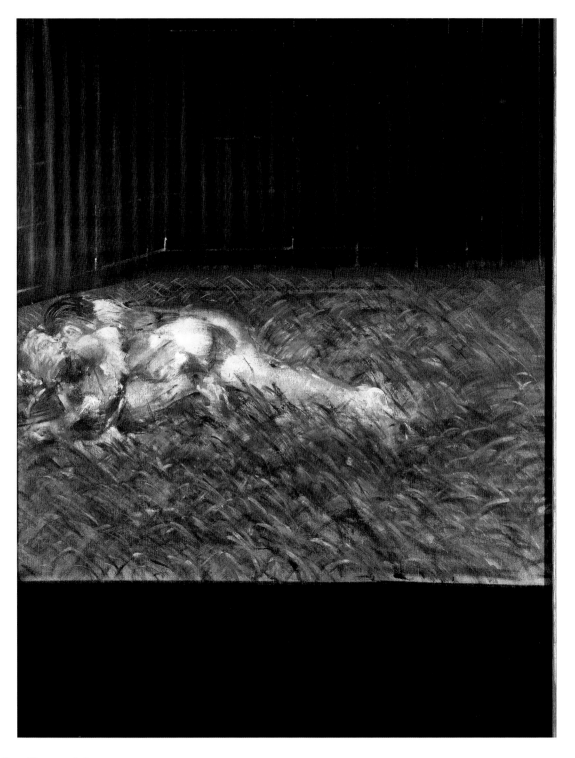

Wrestling match A movement study by the photographic pioneer Eadweard Muybridge forms the basis for *Two Figures in the Grass*, painted a year later than *Two Figures*, which also suggests Muybridge. The long grass is reminiscent of the South African landscapes Bacon was familiar with after two trips to see his mother.

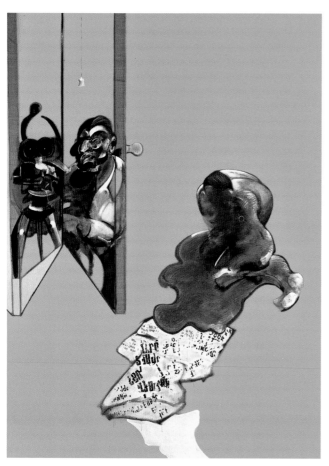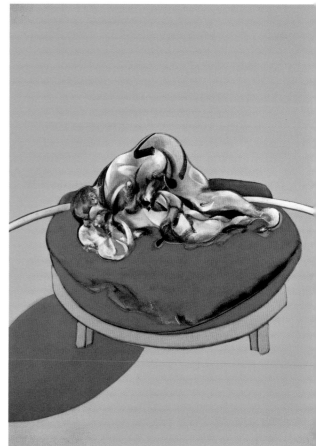

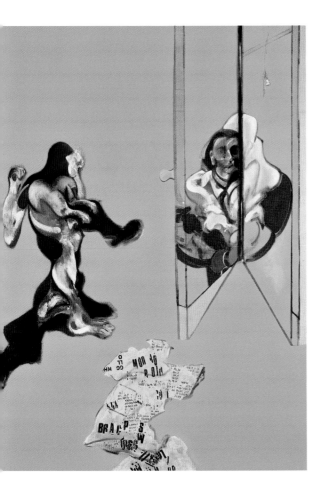

Hidden eye The wrestling men from *Two Figures* and *Two Figures in the Grass* provide the centerpiece for the *Studies from the Human Body* triptych (1970). The flanking figures on the right- and left-hand panels respectively, and above all the cine camera mounted on a tripod, introduce a note of voyeurism. Once more viewers seem to find themselves in the position of a hidden observer.

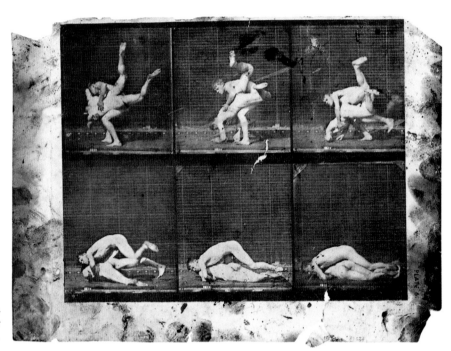

An image torn from Muybridge's *The Human Figure in Motion* with clear signs of use, found in Bacon's studio.

beginning of the 1950s, *Two Figures* and *Two Figures in the Grass* (pages 42-43), which are reminiscent of Muybridge's series showing wrestlers. According to Bacon, "sometimes, if one does not actually look at them through a microscope, they [Muybridge's wrestlers] appear to be in a kind of sexual embrace." The homosexual connotations of Bacon's embracing men—Sylvester calls them "copulation paintings"—prevented the works from being shown publicly for some time. These images of couples also have a personal note because the figures resemble real people from Bacon's circle: "I very often think on people's bodies that I've known. I think of the contours of those bodies that have particularly affected me, but then they're grafted very often onto Muybridge's bodies. I manipulate the Muybridge's bodies into the form of the bodies I have known."

Distorted Features

The medium of photography had a less direct but still compelling influence on Bacon's portraits.

From the early 1950s onwards, his work included images of friends and acquaintances; later he added self-portraits. Bacon rarely requested models to come to his studio so that he could paint them from life. He preferred to paint from memory, using his sense of the person as a guide, though aided by photographs taken by his friend John Deakin, sometimes based on Bacon's specific requests. The physical presence of the portrait's subjects blocked Bacon, preventing him from "drifting as freely as I can." The portraits are often confined to small-format half-length portraits, with the focus firmly on the face. His *Three Studies for Portrait of Isabel Rawsthorne* (1965, page 52) are typical. The deformation and distortion of his subjects' features, characteristic of Bacon's depictions, are not so much acts of violence or a conscious commitment to ugliness. They are, rather, an attempt to capture his perception of the subject, and the model's own perception and state, in order to help us to see the tensions and the living being moving inside, faced with the duality of

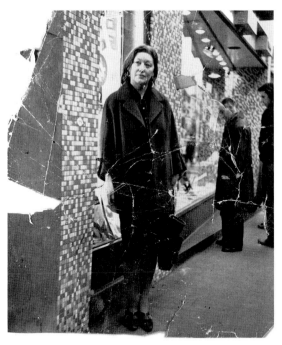

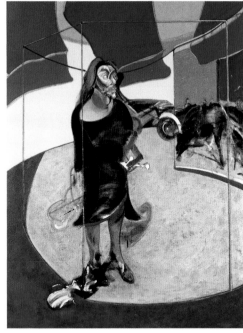

Bacon based his 1967 *Portrait of Isabel Rawsthorne Standing in a Street in Soho* on a photograph by John Deakin.

life and death, its mortality and innate existential crisis. "Isn't it that one wants a thing to be as factual as possible and at the same time as deeply suggestive or deeply unlocking of areas of sensation other than simple illustration of the object that you set out to do? Isn't that what all art is about?"

As he grew older, Bacon increasingly applied his critical gaze to himself. As with the portraits of people close to him, he worked on self-portraits using photographs. Bacon often made derogatory remarks about his own appearance, and cited the deaths of members of his circle, which left him as the only available model, as the reason for the increase in self-portraits. Looking at himself through art could be seen as an act of self-knowledge, with a strong affinity with the work of artists like Rembrandt, whom Bacon greatly admired.

Triptychs

After the mid-1940s, when Bacon establishes himself brilliantly in the art world with *Three Studies for Figures at the Base of a Crucifixion* (pages 24-25), it was some time before he used the triptych form again. As far as he was concerned, the formal division into three panels was less a reference to the triptych's usual religious connotations than a way of isolating figures from each other and destroying the tendency towards narrative. The last thing his pictures are meant to do is to tell stories, to illustrate a set of facts. His works are not aimed at the intellect, but directly at what he described as the "nervous system": he wanted "to give the sensation ... without the boredom of the conveyance."

In 1962, after almost 20 years, he revisited *Three Studies for Figures at the Base of a Crucifixion* (pages 26-27) with *Three Studies for a Crucifixion*. Here, brutality, violence and pain are shown more palpably and directly. Instead of the three self-contained Furies, blood and raw meat dominate the work. The figure in the right-hand panel, a fusion of an animal cadaver and a crucified human, is especially drastic. "I've always been very moved by pic-

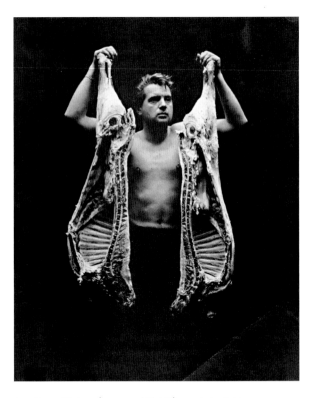

tures about slaughterhouses and meat, and to me they belong very much to the whole thing of the Crucifixion. ... I know for religious people, for Christians, the Crucifixion has a totally different significance. But as a nonbeliever, it was just an act of man's behaviour, a way of behaviour to another." Even if Bacon's triptych is unique in its intensity, art history has other examples of artists fascinated with meat. Rembrandt, Lovis Corinth, and above all Chaim Soutine created images of slaughtered animals with the same force and intensity that can be seen in Bacon's work (pages 50-51). Photographs taken by John Deakin show Bacon himself standing naked to the waist in front of a dark background and holding two gutted animal halves. Bacon also relates *Three Studies for a Crucifixion* to a crucifixion picture by the medieval artist Cimabue that reminded him of a worm crawling down the cross: "I did try to make something of the feeling which I've sometimes had from that picture of this image just moving, undulating down the Cross."

In *Crucifixion* (pages 54-55), painted three years later, the crucified figure was transferred to the central panel. The swastika on the armband of the bowed person on the right suggests a reference to the Third Reich that Bacon himself denied: "It was also, you may say, a stupid thing to put the swastika there. But I wanted to put an armband to break the continuity of the arm ... but it was done entirely as part of trying to make the figure work ... on the level of its working formally."

Coincidence and Control

Bacon could be very disciplined when it came to his work, even if his life was unstable and full of excesses. He woke early every morning and got to work quickly and with concentration. Rarely did his two worlds meet as they did in the case of *Three Studies for a Crucifixion*—Bacon claimed he was very drunk and sometimes barely knew what he was doing when painting this picture. It was not unleashed rage or delirium that made Bacon paint his

Reproduction of a crucifixion by the Italian painter Cimabue (second half of the 13th century), from Bacon's stock of work models.

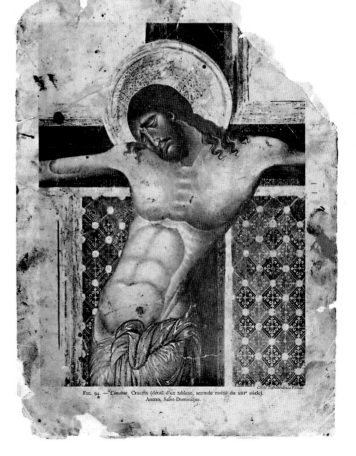

stark, disturbing forms. He described the genesis of his paintings as a combination of coincidence and control, with the picture ultimately decided by instinct and an irrational moment: "If anything ever does work in my case, it works from that moment when consciously I don't know what I'm doing." One consequence of this working method was that pictures changed during the creative process. Bacon explained this, taking his early work *Painting* (page 18) as an example: "I was attempting to make a bird alighting on a field ... but suddenly the line that I had drawn suggested something totally different and out of this suggestion arose this picture. I had no intention to do this picture; I never thought of it in that way. It was like one continuous accident mounting on top of another."

Figure and Space

As well as the small-format portraits, Bacon also painted large-format works, including some triptychs, showing members of his circle. In contrast to the small half-length portraits, which concentrate on the facial features, the whole figure is central to the large-format works. And in contrast to the generally homogenous backgrounds in the portraits, in the larger works the surrounding space contributes to the overall composition. *Three Figures in a Room* (1964, pages 80–81) shows Bacon's partner George Dyer in different situations, including sitting naked on the toilet. The distortions and disrupted shapes

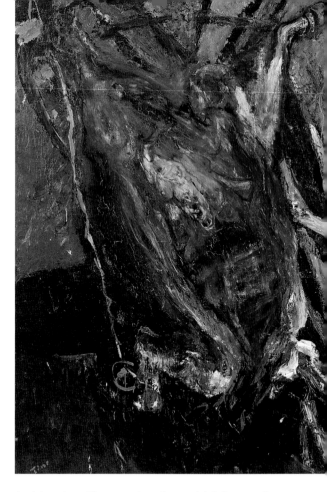

are applied to the whole body, shown in a bare room, isolated except for a few pieces of furniture. Drastically reducing the surroundings was a conscious stylistic ploy by Bacon, intensifying the figure, increasing the picture's intimacy, and presenting a human being's isolation and tragic existence. The room seems like a character in its own right, in a reciprocal relationship with the figure in the portrait. "Every form that you make has an implication, so that, when you are painting somebody, you know that you are, of course, trying to get near not only to their appearance but also to the way they have affected you, because every shape has an implication."

Late Works

The bareness of the spaces, the isolation of the figures, and the quiet oppression were part of Bacon's work to the end. In the 1970s, he expanded his work to include some landscape paintings. For these, too, he created very idiosyncratic spatial situations. *Landscape* (1978, page 57) shows a piece of desert

inside a box-like construction, which in turn is embedded in a colored space typical of Bacon: "I wanted it to be a landscape and look unlike a landscape. And so I whittled it down and down until in the end there was just a little stretch of grass left which I enclosed in the box. And that really came about by trying to cut away, out of despair, the look of what is called a landscape. I wanted it to be a landscape that didn't look like a landscape. I don't know if it all succeeded."

Although his physical strength steadily declined, Bacon continued to paint during his last years. His late works increasingly quote his earlier works, for instance *Second Version of Triptych 1944* (1988, pages 58-59), which completed the circle begun by a work that challenged the art-loving public's visual expectations in earlier years. In Bacon's own

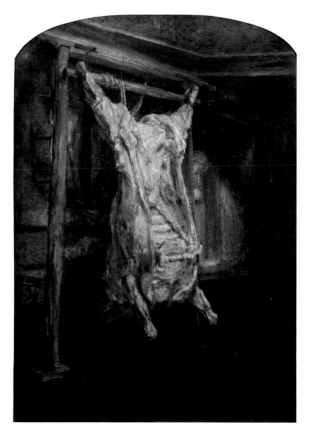

words: "We nearly always live through screens ... a screened existence. And I sometimes think, when people say my work looks violent, that perhaps I have from time to time been able to clear away one or two of the veils or screens." The provocativeness of his work, even in a century full of provocation, is reflected in Pierre Daix' obituary for Bacon, which appeared in *Le Quotidien de Paris* after his death: "He is difficult to classify precisely because he was one of the few painters of the second half of the century who knew how to expand the boarders of painting and who knew, like no one else, the violence, the vice, the despair of integration."

Bacon was not alone in his fascination with raw meat. Rembrandt van Rijn used a slaughtered ox a subject of one of his paintings as early as the 17th century.

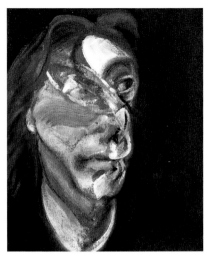 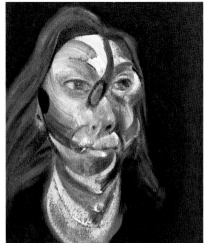 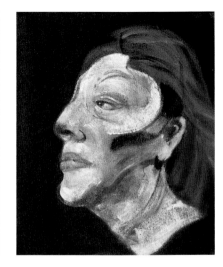

Portraits of a female friend Isabel Rawsthorne was very close to Bacon. Despite the distorted features and the austere structure of this tripartite portrait, painted in 1965—Bacon himself compared it with "police mugshots"—the work still exudes closeness and esteem.

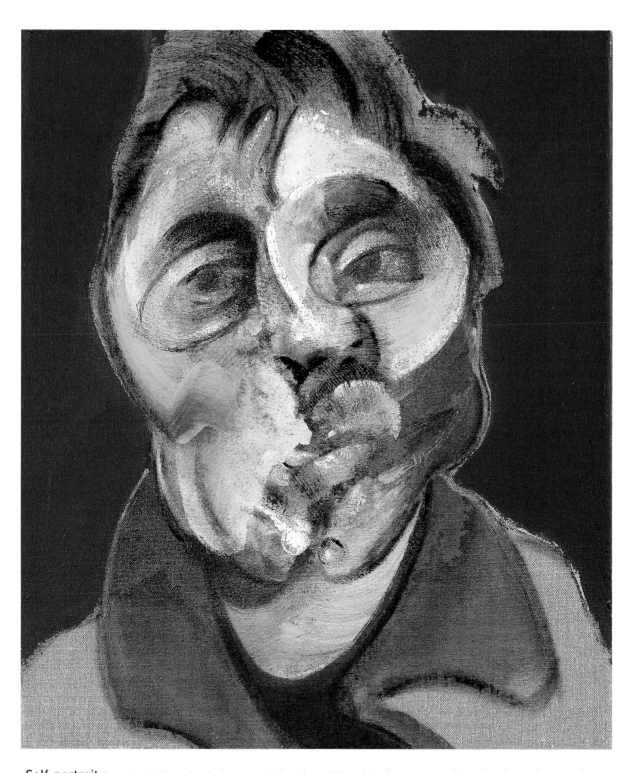

Self-portrait Bacon treats his own face just as unsparingly as those of his models. He was concerned to capture the omnipresence of death in the outward appearance of his sitters, the sense of seconds ticking inevitably away—and he made no exception when looking at his own face.

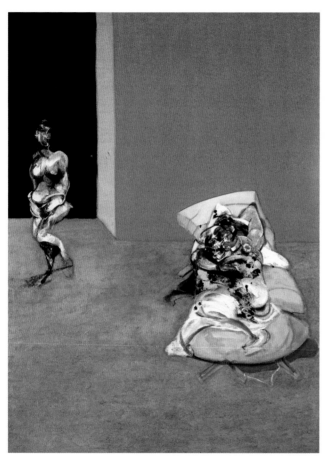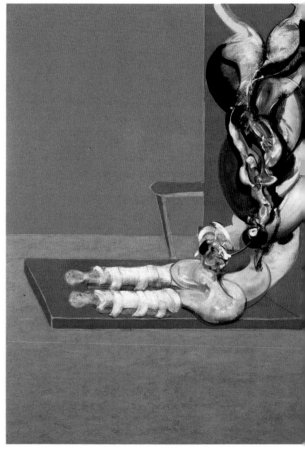

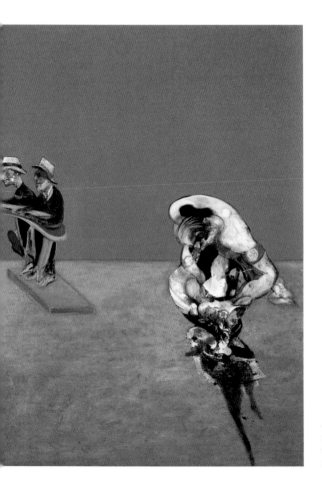

Apocalypse Bacon's 1965 *Crucifixion* shows tortured bodies, isolated and with no hope of redemption. Viewers are subjected to this strangely sterile massacre without any explanation. Is it, as art historian Jörg Zimmermann suggests, an apocalyptic scene: the end of religion, the end of art, the end of humanity?

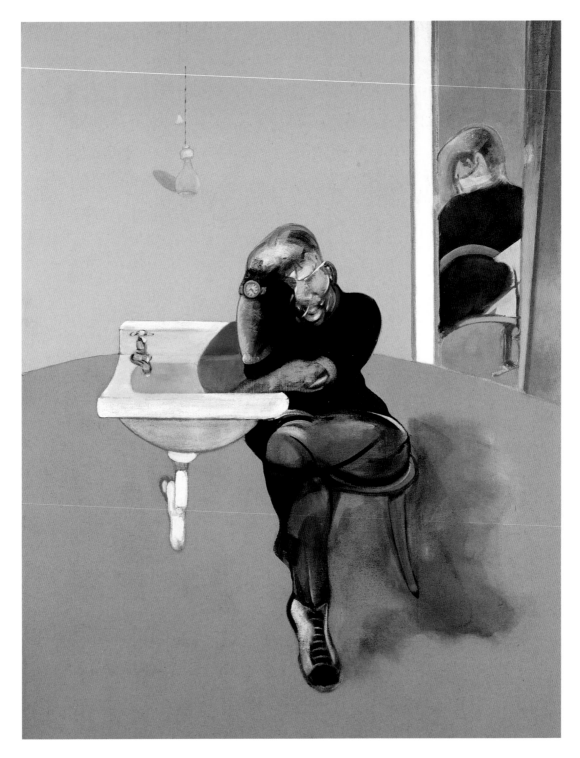

Introspection As with portraits of his friends and acquaintances, Bacon uses photographs as a basis for his self-portraits. His 1973 *Self-Portrait*, showing him by an apparently floating washbasin, borrows from a similarly composed shot by Peter Stark showing Bacon in his kitchen.

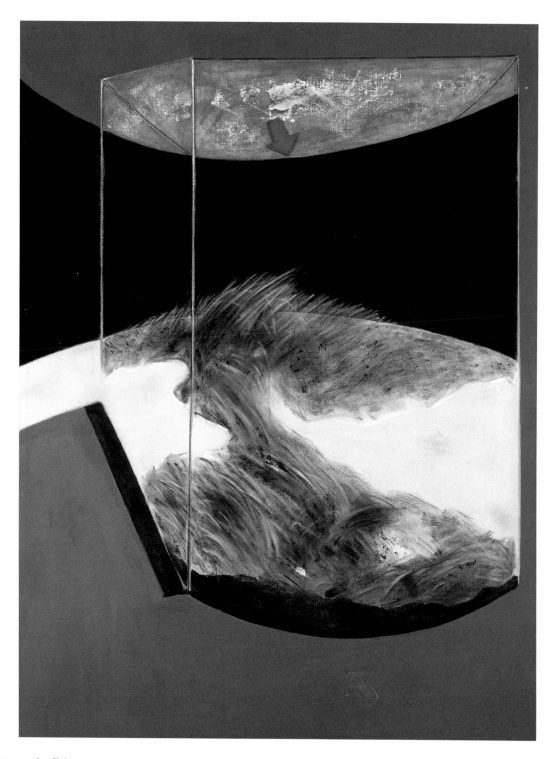

Untamed wilderness David Sylvester mentions "animal energy" in the context of the 1978 *Landscape.* It is the attempt to remove any sense of naturalness from the landscape that allows the tightly bounded area of grass to develop a particular dynamic that lends its circumscribed aspect an all the more powerful impact.

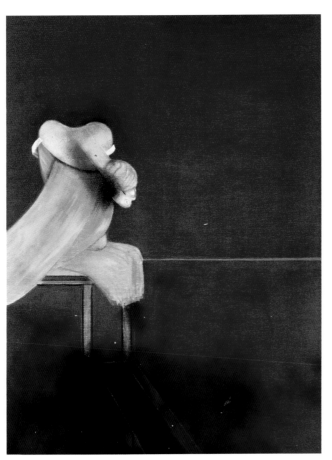

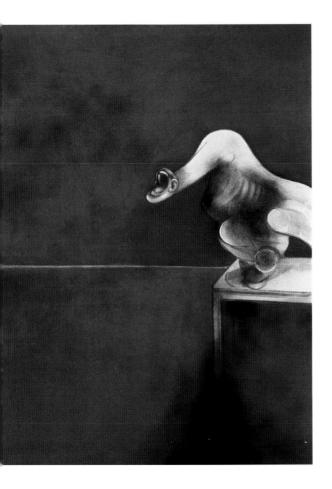

New version The second version of the *Three Studies for Figures at the Base of a Crucifixion*, painted 44 years after the first, seems milder than the original triptych. The dark-red background and the softer forms give an almost romantic feel, but the impenetrability of the distorted figures remains no less alarming.

Life

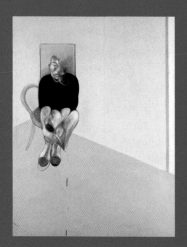

"Existence is in a way so banal, you may as well try and make a kind of grandeur of it."

Francis Bacon

Topography of a Life

Francis Bacon was closely linked with the British capital, London. He lived, loved and worked there, conquering the art world during the day and then roistering through the night in rough company. But the wider world had a pull on Bacon as well ...

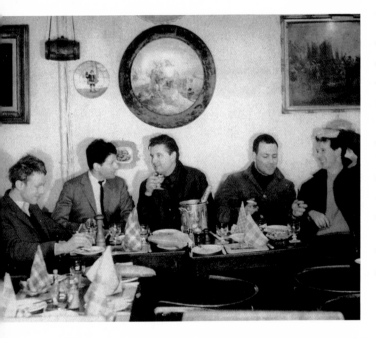

Francis Bacon and friends in Wheeler's, from left to right: Timothy Berens, Lucian Freud, Francis Bacon, Frank Auerbach, and Michael Andrews.

Bacon's Soho

Throughout his life, Francis Bacon's favorite territory was the London district of Soho, and the center for his forays was the *Colony Room* in Dean Street, where the charismatic Muriel Belcher presided behind the bar. Two doors away was the *Caves de France* pub, a haven for "a rich assortment of eccentrics and veteran drinkers ... this was true bohemia." Another important staging post was the *York Minster*, also known as the *French Pub*, run by Gaston Berlemont, whose French father was the first foreigner granted an English pub license. Consequently the *French Pub* was famed for its Pernod, absinthe, and wine—a range that was much to Bacon's taste. Another popular artists' meeting place was the *Gargoyle Club* in Meard Street, which Bacon often haunted with Lucian Freud and John Minton. Bacon was to be found in the traditional fish restaurant *Wheeler's* in Compton Street, famous above all for its oysters, almost as often as in the *Colony Room*. The owner, Bernard Walsh, was a friend of Bacon's and always had a table free if he came in with his entourage. Even when disconcerted guests viewed the boisterous carousing with concern, Walsh kept faith with Bacon and was happy to allow him to pay his outstanding bills, which could run into thousands, in the form of paintings. "I live, you might say, a gilded squalor."

Wanderlust

Though Bacon was firmly rooted in London, he often went off on long journeys, enjoying southern climate. The Mediterranean air in Monaco and on the French Côte d'Azur relieved his asthma, and he could indulge his love of gambling freely in the casino at Monte Carlo. In the early 1950s he twice went to South Africa by sea (his mother had moved there after his father died). His sisters Ianthe and Winnie had settled in nearby Southern Rhodesia (now Zimbabwe). He stopped in Cairo on the way back from his first trip to South Africa to look at masterpieces of Egyptian art, which he felt to be unsurpassed. The Moroccan town of Tangier held a particular significance for Bacon. He even lived in Tangier for an extended period, as his partner Peter Lacy earned his living there as a bar pianist. Bacon was also closely attached to the French capital, Paris, which he had visited as a young man. He bought a small flat in the rue de Birague, near the Place des Vosges, in 1974. Towards the end of his life Bacon discovered Spain—not least because he had a relationship with a young Spaniard.

London Addresses

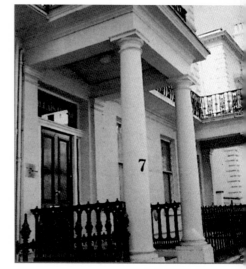

Bacon was born in Ireland, but made London his adopted home at an early age. He settled in the London district of Kensington in the late 1920s, for a long time sharing his home with Jessie Lightfoot, his nanny, who helped him though several moves before dying in 1951. Bacon and Jessie moved into a flat at 71 Royal Hospital Road in the early 1930s, after a short phase in Hampshire, then in 1942 took 7 Cromwell Place, where the painter John Everett Millais used to live (photo right). The charm of the rooms lay in their accumulated patina, and they provided an ideal backdrop for a little illegal gambling den that Bacon and Jessie ran there with Bacon's friend Eric Hall. Bacon's *Three Studies for Figures at the Base of a Crucifixion* was created here, a work that introduced him to a larger public. Bacon sold the flat after Jessie died, then lived a very unsettled life for some years before moving in with friends in Battersea. From there he moved into 7 Reece Mews, where he was to live and work for the rest of his life. Even when he later acquired a spacious house in Roland Gardens, he still made his home in the spartan rooms at Reece Mews.

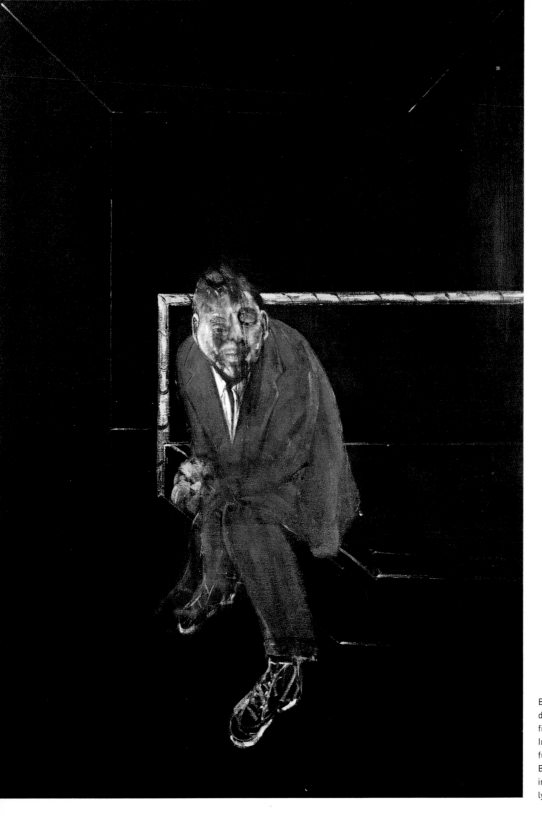

Bacon's *Self-Portrait* dating from 1956 is the first surviving self-portrait. In contrast with the later full-figure self-portraits, Bacon here painted himself in front of a gloomy, scarcely defined background.

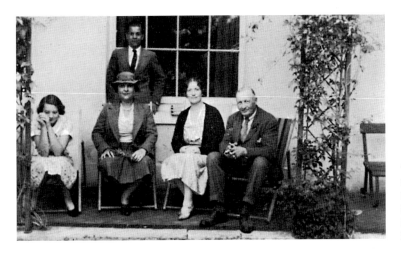

The Bacon family: Bacon's father, Edward, is sitting on the far right, his mother, Christine, is next to him; then an employee and Bacon's sister, Ianthe. His younger brother, Edward, is standing at the back.

Swimming Against the Stream

Francis Bacon's life was full of extremes. He moved between worlds, paying little attention to social conventions, and was as at home in the high-class Monte Carlo casino as in the pubs of Soho. It is not for nothing that his fellow artist Brian Clarke said of him "this old guy was the most violently full-on punk that I knew."

An Irish Childhood

Given Francis Bacon's extravagant lifestyle, his taste for alcohol and gambling, and the generally not very refined company he kept, it may come as a surprise that he came from a well-off family. He was born on 28 October 1909, the second son of Christine Winifred Firth and Edward Anthony Mortimer Bacon, both English, in Dublin. The family name has a ring to it for Edward could trace his family tree back to the Elizabethan statesman and philosopher Sir Francis Bacon (1561–1626).

> "I don't think people are born artists; I think it comes from a mixture of your surroundings, the people you meet, and luck. It is not hereditary, thank goodness."
>
> **Francis Bacon**

left: Francis Bacon as a
young man in Ireland.

right: Francis Bacon's mother,
Christine Winifred Bacon.

Bacon, his two sisters and two brothers spent most of their childhood in the rural county of Kildare in Ireland. His father, an ex-military man, bred and trained racehorses. When the First World War broke out, Edward Bacon was called to the War Office and so the family had to move to London. After the war, they divided their time between England and Ireland. For a few months, Francis attended the Dean Close School in Cheltenham, England, and probably also benefited from private lessons, but did not receive a formal education.

Although Bacon did not speak much about his family later, his biographer Daniel Farson suggests that his rejection of convention and religion, as well as his aversion to living in the country, had their roots in his childhood. His relationship with his parents was bad, and so the most important person in his life became his nanny: "The thing is, I never got on with either my mother or my father. They didn't want me to be a painter, they thought I was just a drifter, especially my mother." When his younger brother died, Bacon saw his father showing emotion for the first and only time.

The Break with his Family

His situation got worse when Edward Bacon caught Francis, then 16 years old, wearing his mother's underwear. He immediately left his parents' home and went to London. To start with, his mother sent him money regularly. He described his first stay in the English metropolis as "between the gutter and the Ritz." Later, he made no

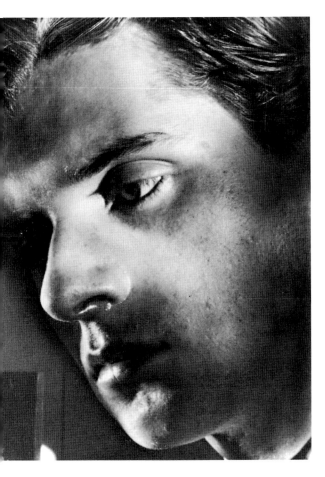

secret of having survived by means of various jobs and minor scams.

Berlin and Paris

In 1926, shortly after Bacon had turned his back on Ireland, his father, making one last attempt to bring up his son by his own standards, entrusted him to the care of a friend of the family, who took the boy on a long trip to Berlin, a city that made a lasting impression on him: "... one of the great decadent years in Berlin. The night was very exciting to me, coming from a very puritanical society like Ireland ..." The two of them live in the Adlon Hotel, Unter den Linden, and enjoyed Weimar Republic exuberances to the full. A photograph taken at the time shows Bacon in profile, his young features thoughtful, his gaze introverted.

After stopping in Munich, Bacon visited Paris for the first time and stayed there for a while. His mentor, who seems to have been half-hearted about his educational duty, leaves the story here. In Paris and in nearby Chantilly, Bacon had his first fateful encounters with art: Picasso's drawings of the time, as well as Poussin's *The Massacre of the Innocents*, both of which would later influenced his painting.

Francis Bacon, Interior Designer

Returning to London, Bacon settled in South Kensington, working as an interior designer, though with only moderate success. One of his clients was the businessman Eric Hall, with whom he developed a close relationship that lasted years. During this time Bacon also got to know the Australian painter Roy de Maistre, who introduced him to Henry Moore and Graham Sutherland. In 1933, after Bacon had abandoned interior design and had begun to paint, he moved to Chelsea. The

The Australian painter Roy de Maistre, photographed in his studio, became a kind of early mentor for Bacon.

Roy de Maistre immortalized the young Bacon in a portrait.

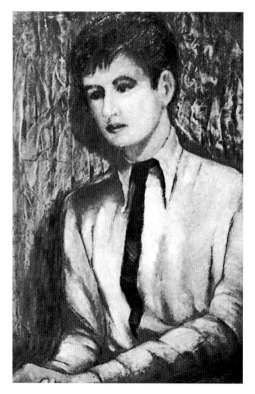

first exhibitions of his work were mostly met with harsh criticism, and for a long time he had strong doubts about his art, at times painting very little. The death of his father on 1 June 1937, and later the outbreak of the Second World War, had little effect on his life. He avoided military service because of his asthma, which he exacerbated by keeping an Alsatian for a while to be sure of being found unfit for service.

Breakthrough as an Artist

After a year's interlude in Hampshire, described by Bacon as unproductive, in 1942 he moved to the former residence of the celebrated pre-Raphaelite artists John Everett Millais in South Kensington, together with his old nanny. Graham Sutherland was now one of his closest friends. Already an established painter, Sutherland was an ardent supporter of Bacon and persuaded Kenneth Clark, the director of the National Gallery, to visit Bacon's studio. In 1945, when *Three Studies for Figures at the Base of a Crucifixion* was included in a group exhibition, the reception of his work finally began to change.

The Colony Room

Around the end of the 1940s, Bacon joined a circle of friends and drinking companions in Soho who were notorious for their dissolute nightlife. They were based in the *Colony Room* owned by Muriel Belcher,

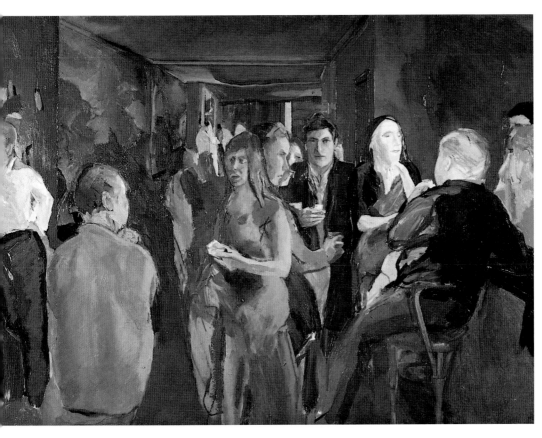

The *Colony Room* was a meeting place for artists and bohemians. Michael Andrews, himself a regular, painted this picture in 1962.

whose astuteness, together with the club's eccentric character, soon made it a major meeting place of bohemian artists and writers. Bacon was a regular from the outset at the *Colony Room*, and at first was actually paid by Belcher to attract an illustrious and heavy-drinking clientele. The relationship between him and Belcher soon became one of mutual trust, as demonstrated by his numerous portraits of her. Another firm member of the *Colony* group, along with the artists Lucian Freud, Frank Auerbach, Denis Wirth-Miller, Michael Andrews, and Isabel Lambert (later Rawsthorne), was John Deakin. Deakin, a heavy-drinking fashion and portrait photographer for *Vogue*, became a close companion of Bacon's, though theirs was a love-hate relationship rather than a deep friendship.

Tangier

In 1950 Bacon traveled to South Africa, where his mother was now living. The year after, his nanny, who lived with him, died. In the years and months that followed, he lived an unsettled life marked by foreign journeys and changes of address, the former fighter pilot Peter Lacy being his closest friend. In 1955 he finally found a long-term place to live in Battersea with his friends Paul Danquah, a lawyer, and Peter Pollack. Tangier became Bacon's favorite destination. For a time in the late 1950s he even took an apartment there, where he could work during his longer visits. During this time, Tangier was a magnet for European and American writers, artists, and the alternative scene because of its permissive atmosphere. There, Bacon met the

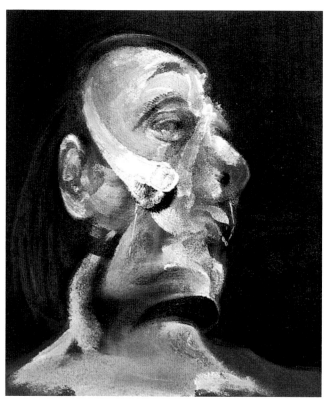 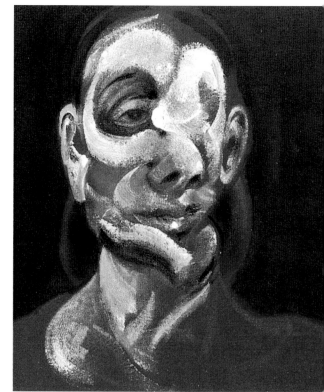

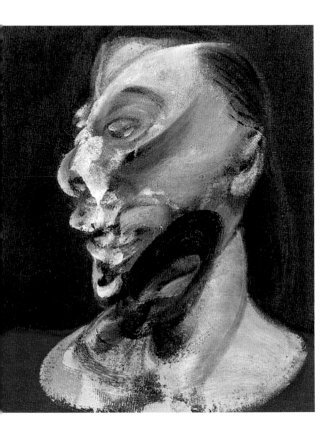

Queen of the night Bacon met Muriel Belcher, who ran the *Colony Room*, which was also known as *Muriel's*, in the late 1940s. This tripartite portrait was painted just under 20 years later. Despite the extreme level of alienation, it captures the charismatic Belcher's striking features.

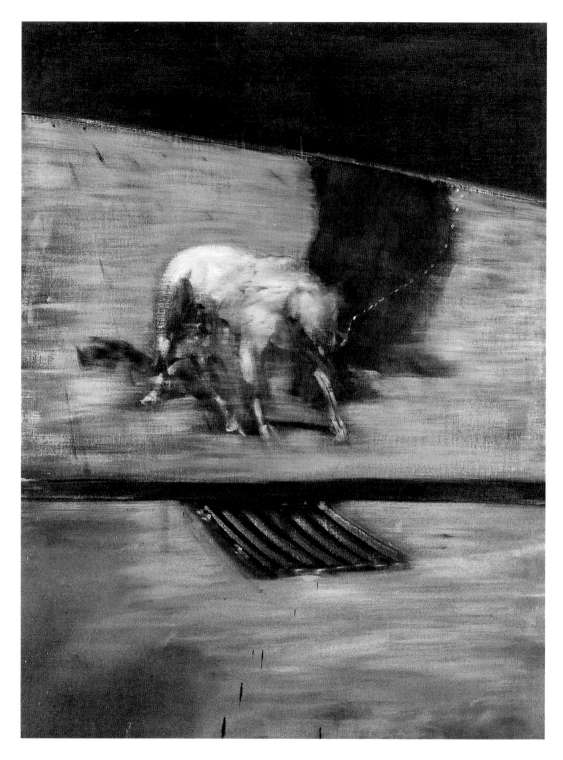

Blurred snapshot The atmosphere of the painting *Man with Dog* is reminiscent of a night scene lit only by the moon. The pale and ghostly dog, whose lead takes the eye to a shadowy figure, is reminiscent of one of Mybridge's photographic series. Bacon's picture shows the creature in front of a street drain, connecting the dark underworld to the surface.

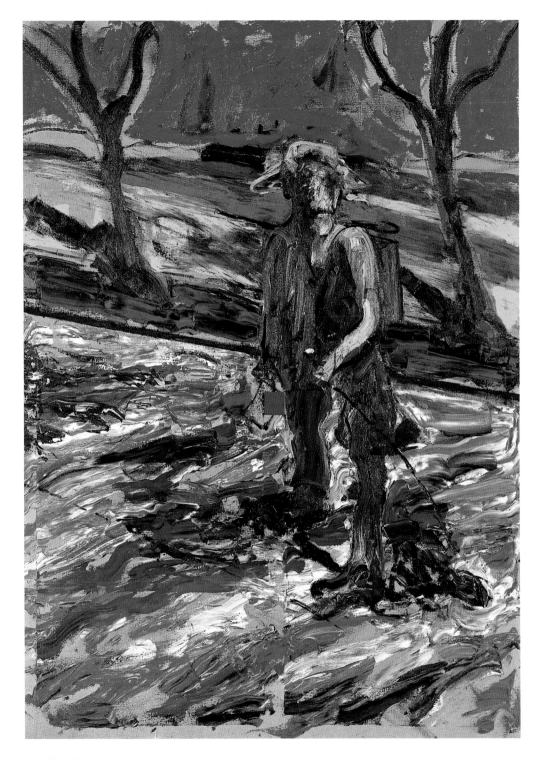

Homage to Van Gogh Starting in 1956, Bacon painted six works in all relating directly to Vincent Van Gogh. *Study for Portrait of Van Gogh III* was painted in 1957 and like the other painting in the series relates to Van Gogh's *The Artist on the Road to Tarascon* (page 6): "... this restless figure that wandered along the street, seemed to me then to be perfect—one could almost say it was the spirit of the street."

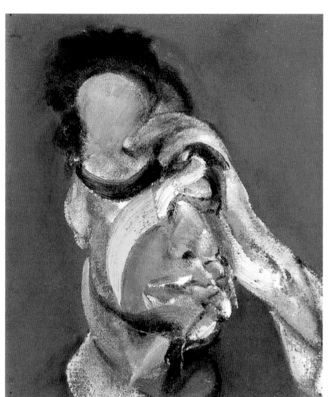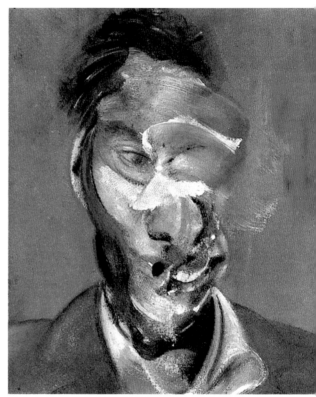

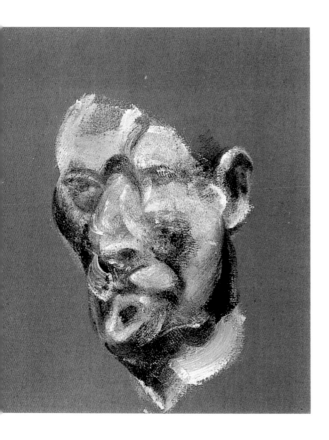

Artist colleague The painter Lucian Freud was a member of Bacon's intimate circle. The *Three Studies for Portrait of Lucian Freud* was painted in 1965 and shows the model in various moods. The head on the right-hand panel is also incomplete, restricted to the face alone, which creates the effect of a mask.

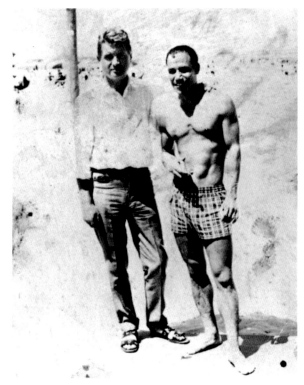

Bacon became friendly with the Moroccan artist Ahmed Yacoubi in Tangier. This photo shows the two men in 1956.

American writers Paul Bowles and Allen Ginsberg, among others, and made friends with the Moroccan artist Ahmed Yacoubi. Another much-frequented destination was Monte Carlo, where Bacon indulged his passion for gambling.

Reece Mews, South Kensington

In the autumn of 1961 Bacon moved into a new residence in Reece Mews, South Kensington. The rooms were above a former stables and very Spartan, but they suit him: "For some reason I knew at the moment that I saw this place that I would be able to work here." The studio and the apartment where Bacon would live for the rest of his life reveal his very unusual way of living and working. "I feel at home in this chaos because chaos inspires me to paint. And also, I love to live in chaos. If I had to leave this place and use another room, it would be chaos in a week. I like it when things are clean, I don't want totally dirty dishes and things, but I love a chaotic atmosphere." Only close friends were al-lowed into Bacon's domain. Many were surprised at first by the hopeless chaos in the studio and the rather bare, comparatively neat living space. With their basic furniture, the relatively small rooms—a combined bathroom/kitchen and a bedroom—also gave no clue to Bacon's increasing wealth. For Bacon, luxury did not lie in extravagant materialism, but in simple things, such as the freedom to be generous to friends.

Paris

Bacon's partner Peter Lacy died in 1962. Two years later Bacon met George Dyer, who was to be the

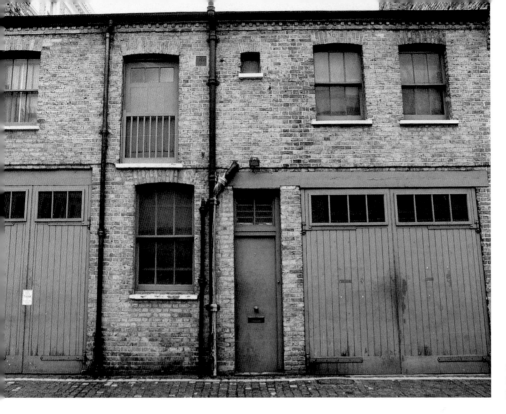

Exterior shot of 7 Reece Mews, which Bacon moved into in 1961.

center of his emotional life for some years. In 1968 he made his first journey to the USA, to see an exhibition of his works in the Marlborough Gallery in New York, accompanied by Dyer. Despite Dyer's psychological ill health, the visit went well. All 20 of the paintings on display were sold within the first week.

In the spring of 1971, Bacon's mother died in South Africa. In the autumn of the same year, his triumphant retrospective opened at the Grand Palais in Paris. However, his artistic success was overshadowed by personal tragedy. Two days before the exhibition opened, George Dyer committed suicide in the hotel room he shared with Bacon. Despite this painful event, for Bacon Paris remained an inspiring city. He often visited, and eventually got himself a permanent address there.

Farewell

The series of deaths among those closest to Bacon continued. John Deakin, whose health had been bad for some time, was diagnosed with lung cancer, and in 1972 underwent an operation; Bacon sent him to the seaside spa of Brighton to recover. After a night of drinking, Deakin died there in his hotel room. As he had given Bacon as his next of kin when checking in at the hotel, Bacon had to travel there to identify him: "It was the last dirty trick he played on me." Despite their sometimes difficult relationship, Bacon still spoke highly of the photographer's talents years later, and classed his portraits with those by Nadar and Julia Margaret Cameron. John Edwards took on the role of favored photographer from 1974 onwards and, as a friend, also helped Bacon in all other aspects of life.

In 1976, four interviews David Sylvester had conducted with Bacon between 1962 and 1974 were published in book form. These conversations, which were reprinted and expanded several times over the next few years—the last version to be printed includes nine interviews and was translated into several languages—became one of the most

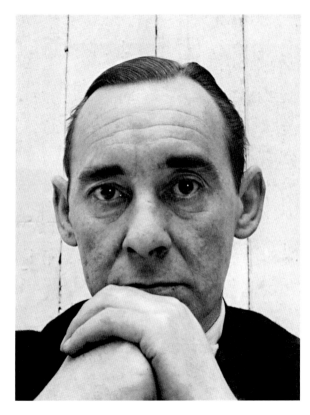

important sources for understanding not only
Bacon's art, but also the wider world of 20th-
century art.

Death in Madrid

Growing old, and with his circle of friends from Soho
decimated, Bacon was sometimes plagued by lone-
liness, despite his steadily growing success. His old
friends were either dead or estranged; he had long
since parted company with Graham Sutherland, for
instance, and late efforts to make peace with him
had failed; he had also lost touch with his one-time
close friend Lucian Freud. Physical deterioration—
he had recently had a kidney removed—limited his
work, though he continued working until his death.
In April 1992, while staying in Madrid, Bacon had to
be taken to hospital due to an inflammation of the
lungs and severe asthma attacks. Six days later he
died there of a heart attack.

Fading Quietly Away

Bacon had a relaxed attitude to death. Daniel Far-
son actually began his biography of Bacon with the
quote: "When I'm dead, put me in a plastic bag and
throw me in the gutter." According to Farson, his
death—he faded away quietly—probably bears out

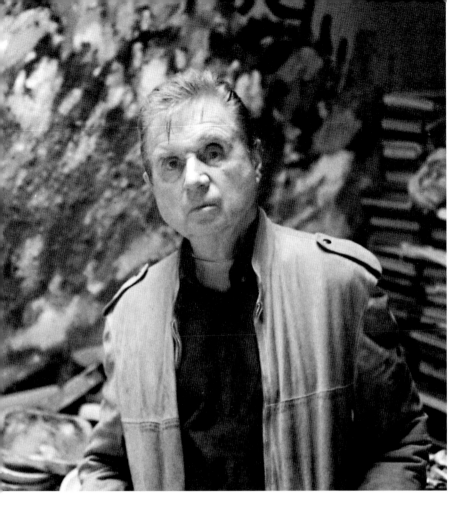

Francis Bacon in his studio. In the background is a wall used as a palette.

this attitude. One of the most moving farewells to Bacon was written by David Sylvester in the *Independent*: "Since he died, I've not thought about him as a painter. I've only thought about the qualities which have long made me feel he was probably the greatest man I've known, and certainly the grandest. His honesty with himself and about himself; his constant sense of the tragic and the comic; his appetite for pleasure; his fastidiousness; his generosity, not only with money—that was easy—but with his time; above all, I think, his courage. He had faults which could be maddening, such as being waspish and bigoted and fairly disloyal, as well as indiscreet. But he was also kind and forgiving and unspoiled by success and never rude unintentionally."

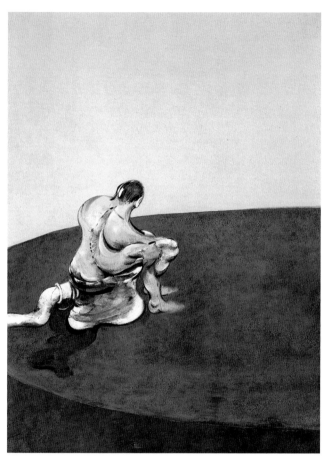

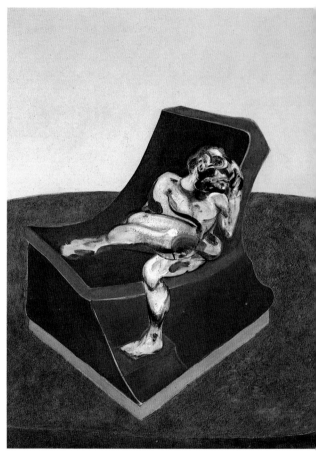

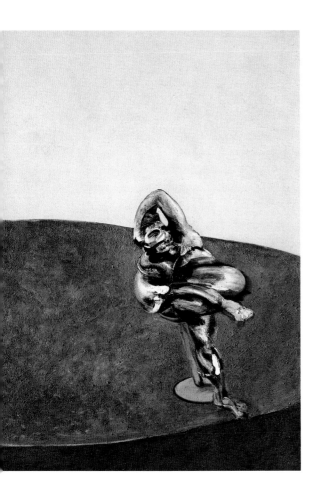

Coincidence *Three Figures in a Room* dates from 1964 and shows George Dyer, whom Bacon had met shortly before. The emptiness of the room, which persists in all three parts, draws all the attention to Dyer's naked and distorted body. The left-hand panel is particularly significant in retrospect: Dyer was to be found dead seven years later in exactly the same position, sitting on the toilet in a Paris hotel room.

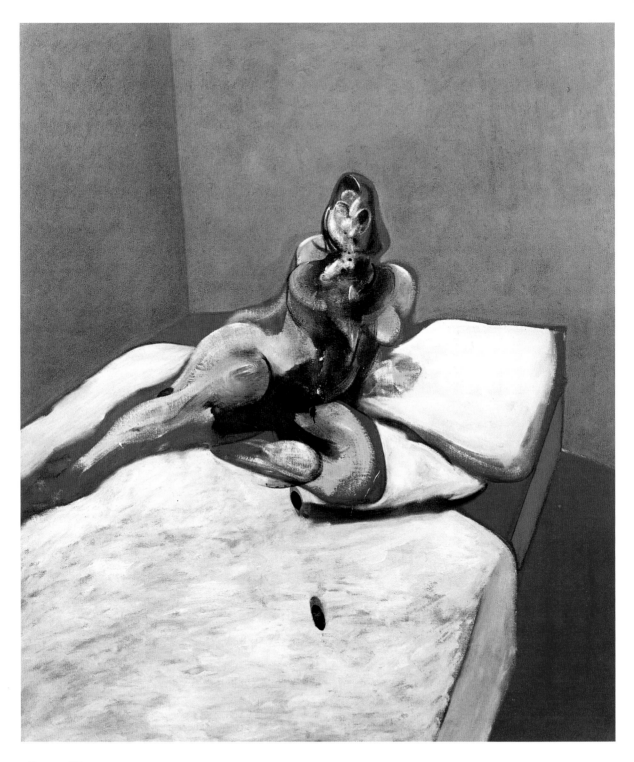

Sensuality In *Portrait of Henrietta Moraes*, the self-declared muse of the *Colony Room* artists' circle is lying naked on a bed, her body presenting a provocative challenge. This portrait of Moraes goes back to a series of photographs that John Deakin took of her at Bacon's request.

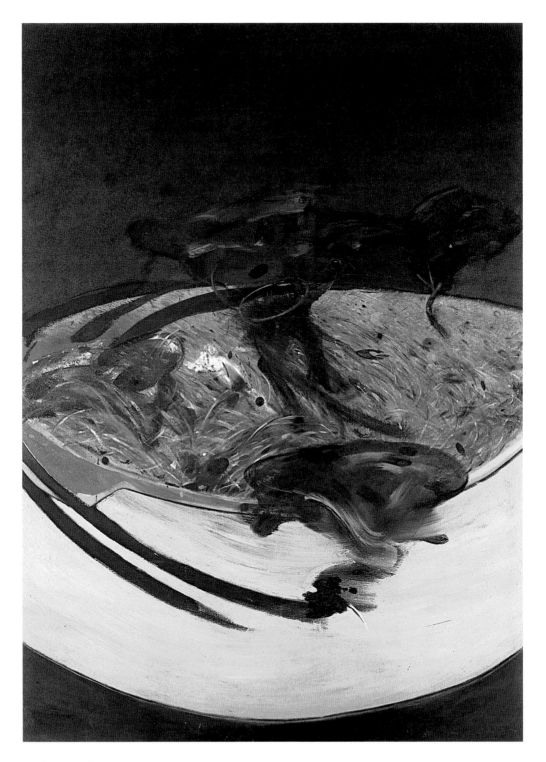

Moroccan impression *Landscape near Malabata, Tangier* was painted in 1963 in memory of Bacon's long stays in the Moroccan city of Tangier. Bacon blamed the intense North African light for the fact that his productivity more or less came to a standstill there. The special light is expressed by a palette unusual for Bacon, characterized by earthy shades and the combination of red and green.

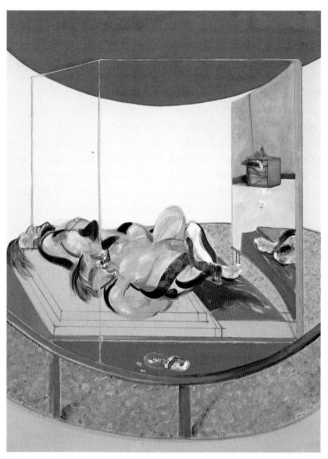
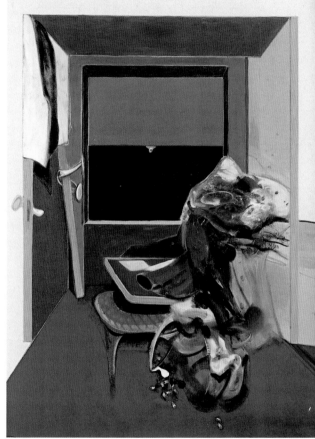

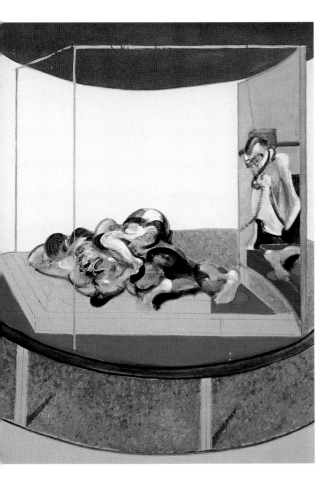

Words and image The title of this painting, *Triptych Inspired by T.S. Eliot's Poem "Sweeney Agonistes,"* was not chosen by Bacon, but by employees of the Marlborough Gallery after Bacon told them he had been reading T.S. Eliot's poem. Even though no direct connection between Bacon and Eliot has been confirmed, individual elements of *Sweeney Agonistes*—for example the citing of "birth and copulation and death" in one line—can definitely be related to the picture.

Love

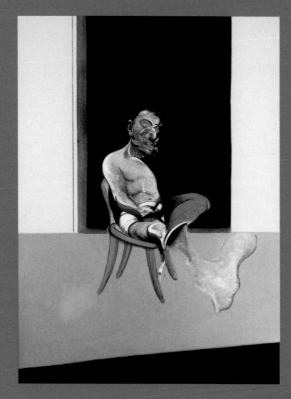

"I painted
to be loved."

Francis Bacon

The Strange Game of Love

Bacon's private life was eventful, his circle of friends full of personalities as eccentric as his own. Although relationships with men dominated his love life, there were also several women among those closest to him.

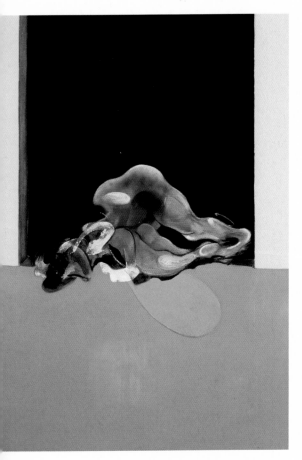

Hard Times

Until the second half of the 20th century, homosexuality in London was restricted to the underground scene, as homosexual acts were illegal. The arrest of the British-Canadian journalist Peter Wildeblood in January 1954, accused, together with Edward Montagu (Lord Montagu of Beaulieu) and Michael Pitt-Rivers, of committing "indecent acts" with two members of the Royal Air Force, became a sensation. The court case, like the arrest, was highly publicized, and ended with all three men being sentenced to prison. Wildeblood was one of the first men in Great Britain to publicly declare his homosexuality in front of the court and press, and he later wrote a book based on his experiences, *Against the Law*, in which he argued for the legalization of homosexuality.

Despite the restrictive atmosphere of British society in his day, Bacon was not afraid of making homoerotic allusions in his work, as here in the central panel of *Triptych, August 1972*.

Bacon and Women

Bacon did not hide his homosexuality. He had no sexual relationships with women, but many close women friends and confidants played an important part in his life.

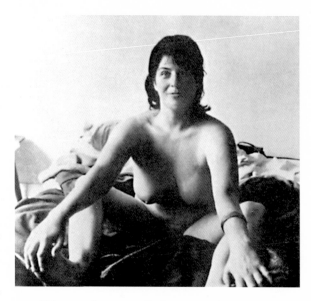

-→ **Muriel Belcher:** was the founder of the *Colony Room*, Bacon's favorite Soho bar. She was the *grande dame* and the life and soul of this artists' meeting place, and had an unerring instinct for attracting the right clientele. Her androgynous aura gained her many admirers, especially among the homosexual regulars, and her brusqueness towards unwelcome guests was legendary. Bacon, who soon became a fixture at the *Colony Room*, immortalizes Belcher in several paintings.

-→ **Henrietta Moraes:** worked as a model for several London art schools and was a regular at the *Colony Room*. She was the muse of several artists during the 1950s and 1960s, including Lucian Freud, with whom she supposedly had an affair. Bacon was impressed by her hedonism and her temperamental nature. He commissioned a series of provocative nude photographs of her by John Deakin, on which he based several of his paintings.

-→ **Isabel Rawsthorne:** trained as an artist in Liverpool and at the London Royal Academy. She became the assistant and later the partner of the sculptor Jacob Epstein. She lived in Paris, where she worked with André Derain and later Alberto Giacometti. Rawsthorne's first marriage was to the journalist Sefton Delmer, her second to the composer Constant Lambert, and her third and final marriage was to Alan Rawsthorne, also a composer. A close friend of Bacon's, she was the subject for several of his portraits.

-→ **Valerie Beston:** was a member of staff at the Marlborough Gallery, London, where she managed sales of his works. Her organization of Bacon's life went far beyond this, however—it was Beston who made sure his rent was paid on time, settled his bills at Harrods, arranged doctor's appointments, and continually had completed works removed from his studio so that he could not destroy them out of dissatisfaction. In her obituary, her close connection with Bacon was even described as "a kind of professional marriage."

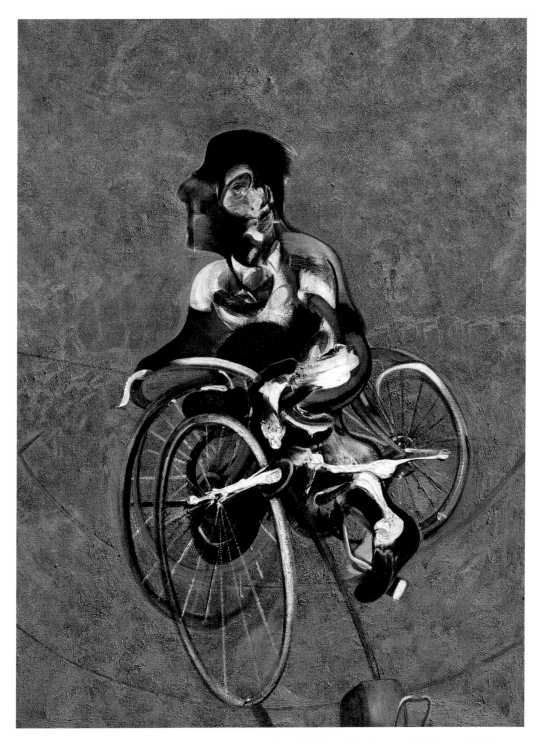

The *Portrait of George Dyer Riding a Bicycle* shows an unusual motif for Bacon: Bacon's partner is sitting on a bicycle, and the composition contains an unusual dynamism and movement (the front wheel is reproduced three times). The tracks made by the bicycle suggest a circus tightrope rather than a road.

John Deakin photographed Bacon and George Dyer in Soho around 1966.

"There are only sexual obsessions."

Bacon's personality remains a mystery, not least because he seldom gave any information about himself and his emotional life. On the other hand, he never made a secret of his homosexuality, which is also a theme in his art. Despite his sometimes permissive lifestyle, he had several close, long-term relationships that inspired him precisely because of their drama.

Ambivalent Personality

Francis Bacon was a mass of contradictions. Despite his work's gloomy aura he called himself an optimist. He cultivated solitude and loved company, and was a good friend to many people, though his affection could quickly change to open antipathy—rival artist in particular were often exposed to the temperamental side of his nature. "I've always thought of friendship as where two people really tear one another apart and perhaps in that way learn something from each other." Bacon's sharp tongue was

"Even as old as I am, it doesn't stop me from looking at men ... Passion keeps you young, and passion and liberty are so seductive."

Francis Bacon

91

An undated portrait by Roy de Maistre showing Eric Hall, a businessman with whom Bacon had a long relationship.

dreaded, but his generous invitations and unconditional financial support for close friends or partners were equally legendary.

First Experiences

Bacon was fortunate in that homosexuality was entirely acceptable in his immediate circle. This was not exactly inevitable, and was not always the case—the discovery by his father of young Bacon's passion for his mother's underwear was a major reason for his falling out with his family. In retrospect, Bacon put his bad relationship with his father down to his having a subconscious sexual attraction to him, which he only recognized after his first sexual encounters with stable-boys and servants on his parents' estate.

In London, Bacon's first destination after his departure from Ireland, homosexual relations were still a punishable offense. In spite of this, London had a thriving underground scene that helped the still shy and insecure Bacon to live with his own homosexuality and to accept it as part of his identity. Bacon later recounted how in his first London period he worked as a "gentleman's gentleman," a companion for older men, for whom he cooked and cleaned.

Eric Hall

Bacon had his first documented long-term relationship with the prosperous businessman and politician Eric Hall, whom he met in 1929. Hall was enthusiastic about Bacon's work and made a cause of encouraging and supporting the young artist. This usually meant financial support, as Bacon could not yet live on the proceeds of selling his

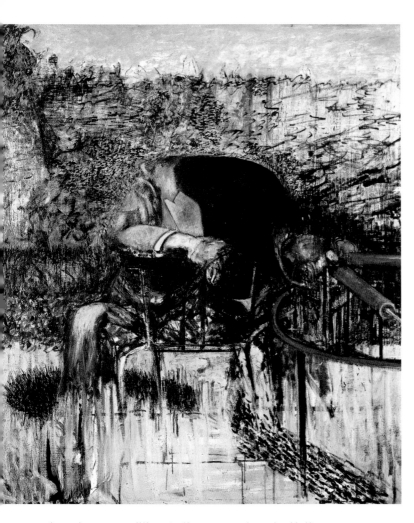

Figure in a Landscape (1945) is based on a photograph of Eric Hall that has not survived.

picture was based on a photograph, now lost, showing Hall sitting in a park, sleepy and dozing off. Bacon alienated his subject with expressive brushstrokes and smudged paint surfaces.

work and was unwilling to live more cheaply. Hall helped him when the casino in Monte Carlo demanded its money, paid his rent, and helped him on the way to becoming a gourmet by introducing him to the world of exclusive restaurants and fine wines. Bacon spoke of Eric Hall as someone who had greatly influenced and encouraged him, as an intelligent man with a lot of sensibility: "He taught me the value of things—decent food and so on." That Hall was married with two children did not stop him from maintaining his relationship with Bacon for nearly 15 years. He helped to organize exhibitions, and was a patron for other aspiring artists as well as for Bacon. In 1945, Bacon immortalized his partner in *Figure in a Landscape*. The

Peter Lacy

The reason why Hall and Bacon's liaison ended is unknown. In 1952 Bacon met the former fighter pilot Peter Lacy, and soon developed an intense relationship with him. Lacy, a reserved old-school Englishman who liked to dress well, had exquisite manners and appreciated a good drink, was not openly homosexual. Bacon also painted several portraits of his new partner, for instance a likeness with the simple title *P.L.* In 1953 Bacon spent the summer close to Lacy's cottage in Hurst, near Henley-on-Thames. From the mid-1950s onwards they spend most of their time together in Tangier. Lacy played the piano there in *Dean's Bar*, a favored

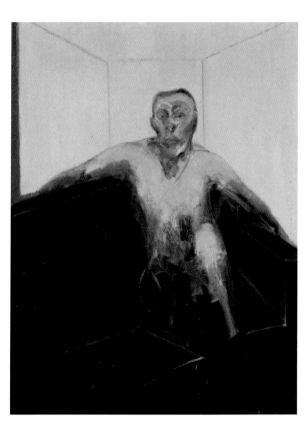

meeting place of the artists and writers in Tangiers, including Truman Capote and Tennessee Williams. His distinguished appearance and discreet manner did not hide the fact that Lacy was a notorious drinker prone to destructive outbursts when drunk. More than once he destroyed some of Bacon's pictures or got involved in a fight. Both Bacon and Lacy apparently had affairs with other men, and not only in Tangier, but their mutual attachment remained strong over several years, sustained by a constant flow of letters whenever they were apart. They began to lose contact only when Lacy's emotional and physical health deteriorated due to his tremendous consumption of alcohol. He died in 1962, on the eve of the opening of Bacon's first retrospective. Bacon learned of his death only after the exhibition opening and by a telegram—it was among a pile of telegrams congratulating him on the retrospective. In spite of the emotional distance that has recently built up between them, Bacon was deeply affected.

George Dyer

About two years after Lacy's death, Bacon encountered George Dyer, a petty criminal from London's East End. The legend, spread by Bacon himself, is that he caught Dyer trying to break into his rooms in Reece Mews. Dyer was good-looking and radiated masculinity, but his outer appearance hid a shy, emotionally vulnerable man who also struggled with a slight speech impediment. The relationship

Lacy shared Bacons love of southern Europe and Africa. This photograph shows him in Ostia, Italy.

of money, took him with him when he travels, and painted over 40 pictures of him, including *Portrait of George Dyer Crouching*, *Portrait of George Dyer Riding a Bicycle*, *Portrait of George Dyer in a Mirror*, *Two Studies for a Portrait of George Dyer*, and *Portrait of George Dyer Staring at a Blind Cord*. When the relationship increasingly deteriorated and Bacon publicly had other affairs, Dyer was overcome with jealousy. Difficulties escalated when Bacon was visited by the police, who searched his flat and studio. Although cannabis was found and Bacon was under arrest for a brief period, no charges were brought due to a lack of evidence. It soon became clear that Dyer was behind the

between Bacon and Dyer was ill-fated from the start. Photographs taken on the Orient Express showing their intense closeness cannot hide the conflict and physical violence that was part of their passionate relationship from the beginning. Like Peter Lacy, Dyer drank heavily and was plagued by depressive episodes. Despite this, he fascinated Bacon, who tolerated these emotional outbursts for some time. He was constantly giving the penniless Dyer large sums

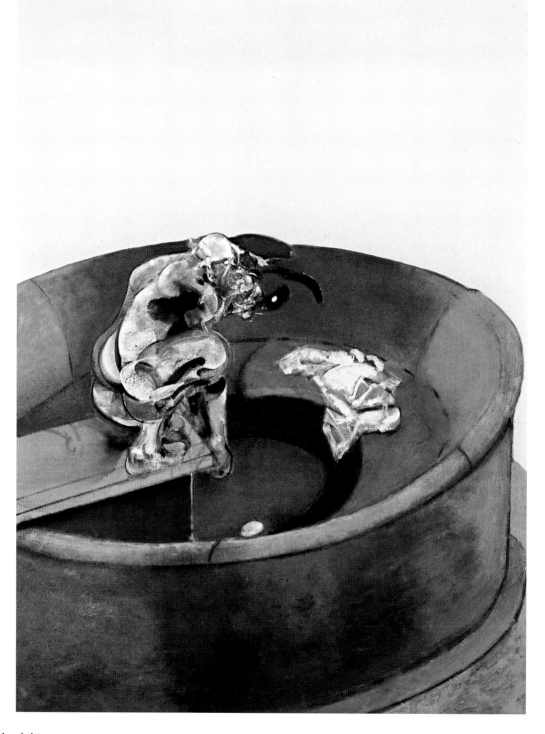

In his sights Like Michael Peppiatt before him, the critic John Russell also describes Bacon in a critique of *Portrait of John Dyer Crouching* as a hunter stalking his prey: "He has stalked ... as the hunter in the jungle stalks the living prey. ... The figure in the painting has nothing to do and nowhere to go. The evident coiled power within him has no outlet: his activity, such as it is, is dissociated from any imaginable rational end."

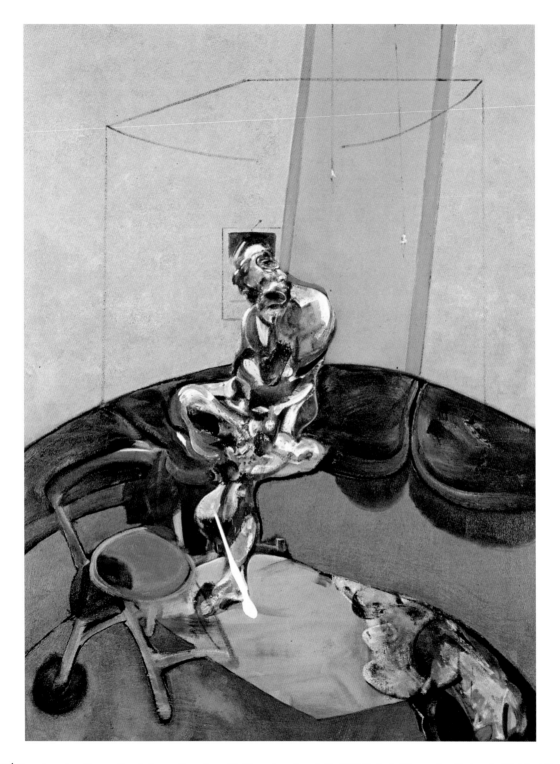

Lost Bacon's partner George Dyer is frequently portrayed in his work, as here in the 1966 *Portrait of George Dyer Staring at a Blind Cord*. Bacon was fascinated by Dyer's rugged masculinity, which was combined with shyness and uncertainty. None of his models was portrayed as so existentially isolated and lost.

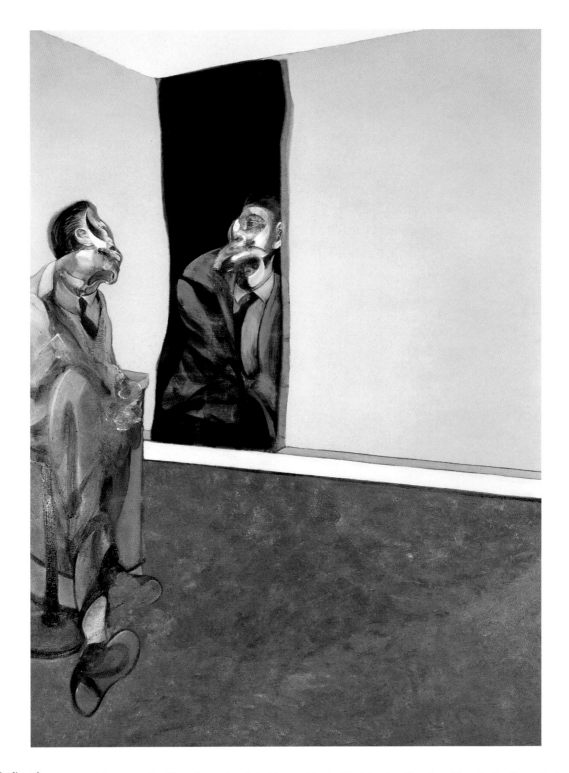

Reflection In *Study of George Dyer in a Mirror*, George Dyer is looking over his shoulder into a box-like mirror. The reflection throws back Dyer's profile, which does not match the pose of the figure, and is divided into two by a sharp cut, possibly an allusion to the subject's unstable personality.

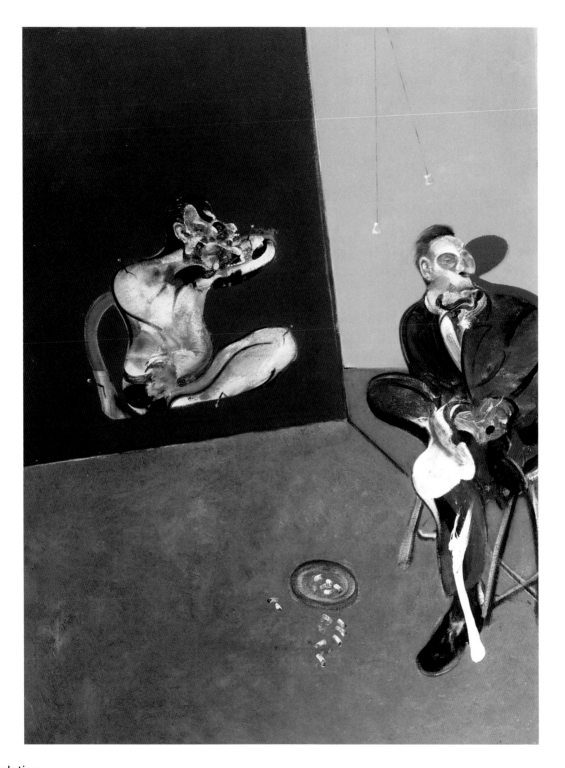

Isolation *Two Studies for a Portrait of George Dyer* shows Bacon's partner sitting on a chair, with a full ashtray in front of him and cigarette ends scattered on the floor. Another painting depicts a seated Dyer leaning against the wall, this time naked and cut off just above the hip. Bacon himself describes his models as "always isolated, shut in, 'reduced to images,' as if they had to convince themselves of their own existence."

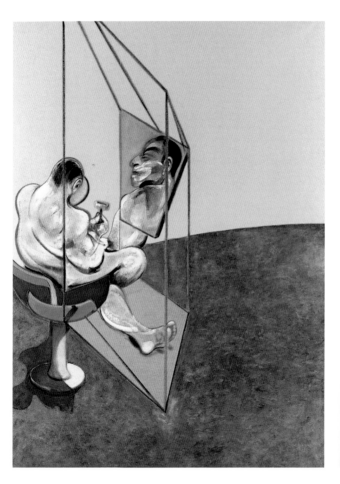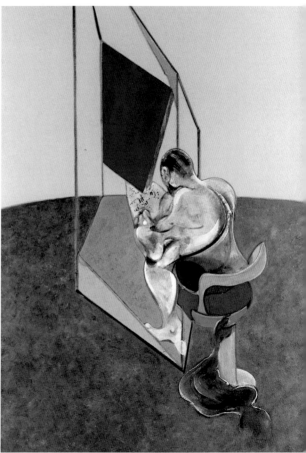

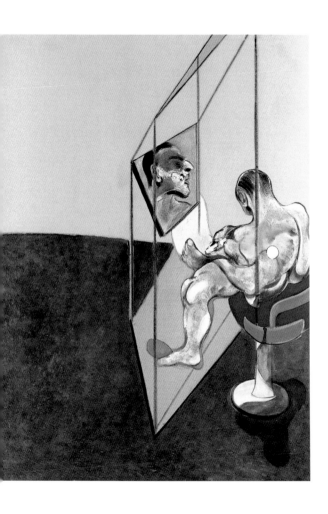

Ordinary Bacon himself said that he was attracted by presenting people "in their most everyday, ordinary lives": sitting down, looking in the mirror, on the toilet, cycling, or, as here in *Three Studies of the Male Back*, shaving or reading the paper. The rigid lines of the mirror contrast starkly with the concise, rounded contours of Dyer's body.

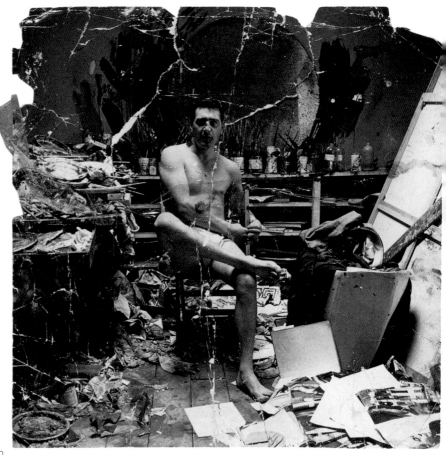

George Dyer sitting in Bacon's studio, photographed by John Deakin. Bacon based several paintings on this photo.

operation and had informed on Bacon. Despite this, they did not break up, and the relationship continued its turbulent course.

When Bacon set off for Paris to prepare for the large retrospective in the Grand Palais in the autumn of 1971, Dyer was with him. They both booked into the Hotel Saints-Pères. Two days before the exhibition opened, Dyer, who was then 37, committed suicide in the room they shared. He was found dead the next day, sitting on the toilet in a shocking condition. A fatal mixture of alcohol and drugs was given as the cause of death. For Bacon, Dyer's suicide echoed the trauma of Peter Lacy's death, which also happened at a high point in his career. Despite the terrible circumstances, Bacon kept to all his engagements in Paris in connection with the exhibition without showing any outer signs of emotion. His way of dealing with the drama was to channel it into his work: "Although one's never exorcized, because people say you forget about death, but you don't. ... time doesn't heal. But you concentrate on something which was an obsession with the physical act you put into your work."

Despite a great deal of conflict, the relationship between Bacon and Dyer was close, as this photograph of the two of them travelling on the Orient Express shows.

Recollections

The first work relating to the tragic death of George Dyer, *In Memory of George Dyer* (page 104), was painted in December of 1971. The central panel of the triptych shows George Dyer unlocking a door. The motif of unlocking appears several times in Bacon's work; he connected it with a passage from T.S. Eliot's poem *The Waste Land* (1922): "I have heard the key / Turn in the door once and turn once only / We think of the key, each in his prison ..." We can be sure that this work also refers specifically to the moment of loneliness, isolation and despair that Dyer felt just before his suicide in that Paris hotel—which the background in the painting may be meant to suggest—a moment that reaches its crisis in the panels to the left and right.

In *Triptych, August 1972* (pages 106–107), Bacon takes Dyer's death as his subject again. The basis for the painting, which shows Dyer in front of a black opening in space, is a photograph by Deakin showing him wearing only his underpants and sitting in Bacon's studio. Finally, *Triptych, May–June*

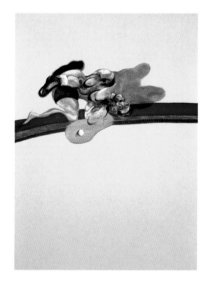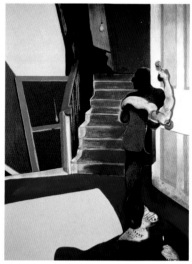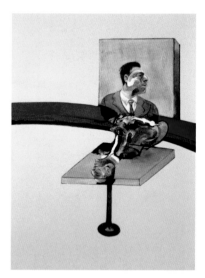

Triptych–In Memory of George Dyer was the first major work addressing Dyer's tragic death. The central panel shows the room in the Paris hotel in which Dyer died.

1973 (pages 108–109), described by David Sylvester as "possibly the most emotionally charged of all Bacon's work," shows Dyer sitting dead on the toilet in the left panel. On the right, he is vomiting over a washbasin. In the middle, the blackness of the room floods demonically out of the doorway. Bacon paid Dyer a final tribute by insisting that one of his portraits of him was used for the catalogue and poster for the second Tate retrospective in May 1985.

John Edwards

In 1974, Bacon met John Edwards on one of his crawls through the pubs of Soho; like Dyer, Edwards came from the East End. They became friends, went out together, and quickly became inseparable. The young, uneducated Edwards was fascinated by Bacon's aura, and Bacon in turn valued the young man's open and carefree nature, and the fact that he could stand up for himself and did not take Bacon's own fits of temper silently. Bacon found his new companion a place to live near Reece Mews, and from then on Edwards supported him in word and deed. Although the relationship may have begun with a love story (Edwards later said there had been no sex involved), it soon became a kind of father-son relationship, filled with a deep friendship and trust. Edwards even had the rare honor of keeping Bacon company while he worked. "When Francis painted there was a drama. It always seemed to me as if he was fighting with the canvas." Edwards was the model for over 30 paintings by Bacon, and in his turn he documented the life

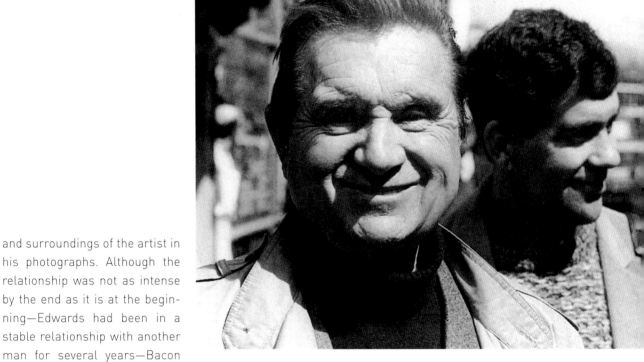

John Edwards became important
to Bacon from the mid 1970s.

and surroundings of the artist in his photographs. Although the relationship was not as intense by the end as it is at the beginning—Edwards had been in a stable relationship with another man for several years—Bacon made him his sole heir. Edwards controlled Bacon's estate after his death, until he himself died in Bangkok in August 2008, after suffering from lung cancer.

The Spaniard

Bacon experienced a last great romance at the end of his life with a young Spanish businessman called José, whose identity remains a mystery. Few people from the London scene actually met the Spaniard. Instead, Bacon went on frequent visits to Spain to see his partner. Bacon died in Madrid, on one of the journeys that brought him happiness so late in life.

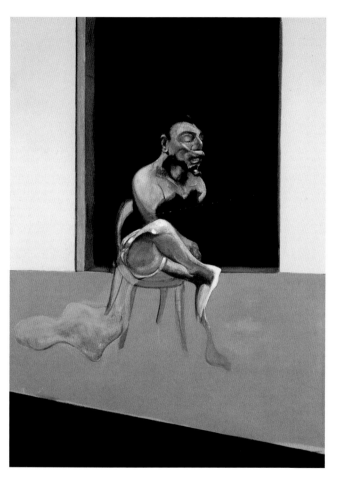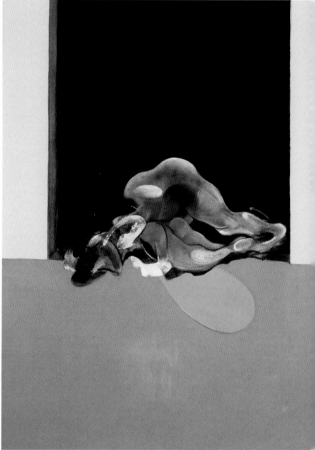

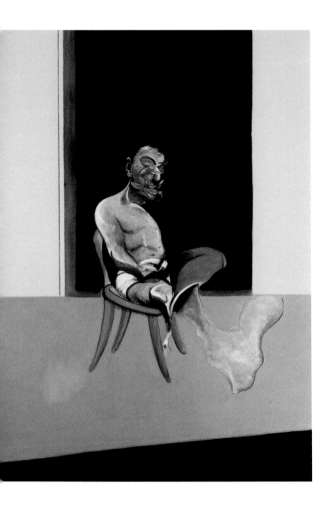

Requiem Bacon pronounced in 1971, shortly after Dyer's death: "My life, up until this point, has actually run an unfortunate course, since all the people who I really loved have died." He is no doubt also referring to Peter Lacy here, with whom he had had a relationship before he met Dyer, and who died before Bacon's just first Tate Gallery exhibition. Lacy's death left no visible traces in Bacon's work, but after October 1971 three triptychs alone were dedicated to George Dyer's life and death. *Triptych, August 1972*, which alludes to a Deakin photograph in both outer panels, is one of them.

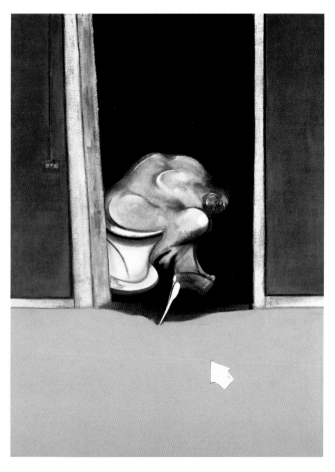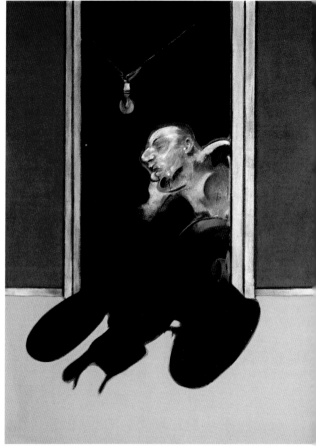

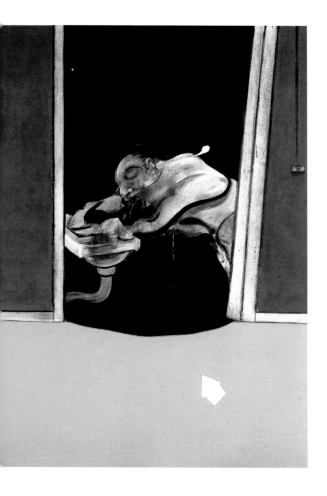

Farewell In an interview, Bacon equated love with obsession: "It is perhaps obsession with a person. ... It can be obsession with certain pictures from the past." The fact that images of George Dyer's last hours were to haunt him for a long time became clear in the works produced after Dyer's death. *Triptych, May–June 1973*, which Bacon himself said of all his pictures came closest to a kind of narrative, depicts his partner's suicide in nightmarish scenes.

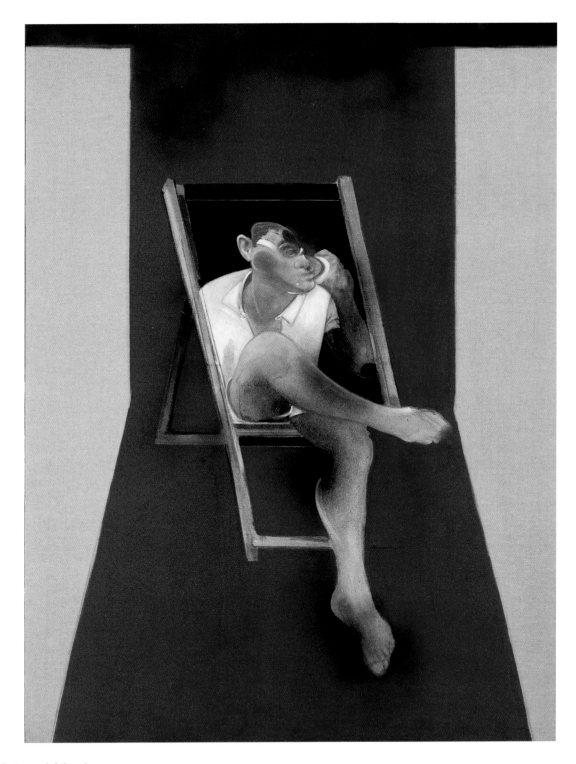

Paternal friend John Edwards, over 40 years younger than Bacon, became his close companion from 1974. In an interview with the London *Daily Telegraph*, Edwards said that "Francis was a real, true father to me. But Francis gave me all the guidance I needed, and we laughed a lot. And I think he liked me because I didn't want anything from him." *Study for a Portrait of John Edwards* (1988) is one of many paintings for which Edwards sat.

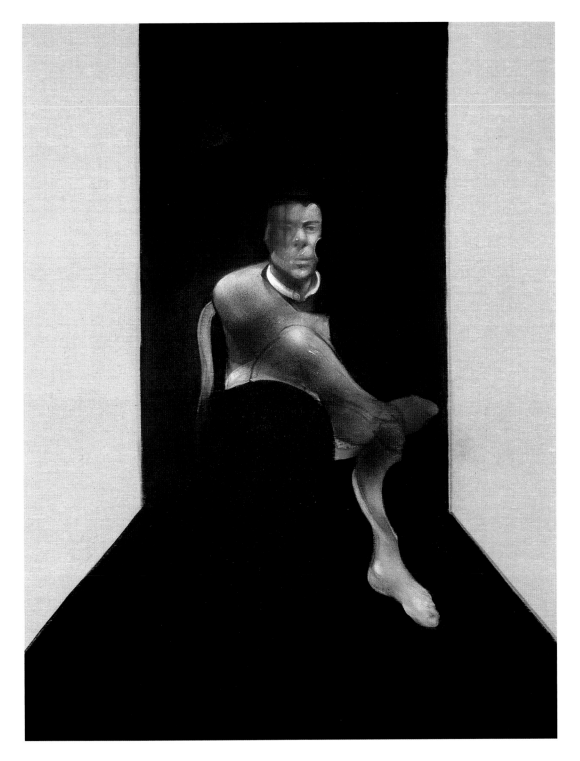

Shadow of remembrance *The work Study for a Portrait of John Edwards*, from 1988, references John Deakin's photographs of George Dyer, who he pictured sitting in Bacons studio wearing only underwear. Edward's head seems to be unattached to his body, the white collar divides the two entities even more.

Bacon Today

"I live
completely
shabbily."

Francis Bacon

Bacon's Legacy

Bacon wisely said that an artist's work can only be truly valued once enough time has passed. Now, over a decade after his death, his work has lost none of its impact. Demand for his paintings pushes prices up to record levels and his pictorial language is echoed in many kinds of creative work.

Bacon and Bertolucci

Bacon's influence does not stop with the fine arts. For instance, the aesthetic of his pictures is incorporated into Bernardo Bertolucci's *Last Tango in Paris* (1973) The film's first scene, accompanied by sounds created by the composer Gato Barbieri, shows two of Bacon's portraits, foreshadowing the isolated and lost characters played by Marlon Brando and Maria Schneider. Bertolucci's film continually connects with Bacon's work through the attitudes, dress and postures of the protagonists. About Paul (Marlon Brando), Bertolucci says: "I wanted Paul to be like the figures that obsessively return in Bacon: faces eaten by something coming from the inside."

Bacon in the Internet

The Estate of Francis Bacon maintains an informative website on the internet that details many aspects of Bacon's life and work. On www.francis-bacon.com you can find several discussions and texts regarding his friends and family, a detailed biography, and video clips where you can listen to Bacon experts and other commentaries.

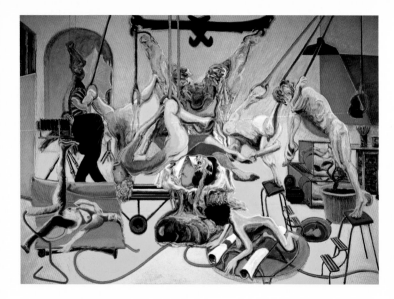

Norbert Tadeusz,
Yellow Studio, 1985

Record price

Bacon's works sold for impressive sums during his lifetime. All the same, he would probably have been surprised by one of his paintings attracting the highest price ever paid for a post-war artwork. He painted only about 600 pictures, many of them now in museums. This means that whenever one of his paintings appears on the open market the demand is very high. In the spring of 2008, when Bacon's *Triptych, 1976* went under the hammer in Sotheby's in New York, the Russian billionaire Roman Abramovich snapped it up. He is willing to pay $86.2 million (including commission) for it, causing Bacon's work to break the record set by Mark Rothko's painting *White Center (Yellow, Pink and Lavender on Rose)*, which changed hands the previous year for $72.8 million.

Inspiration

A second glance at works by the generation of artists who came after him reveals Bacon's influence. In an age dominated by abstraction, his unwavering focus on representational painting blazed a trail for painters like David Hockney and Eric Fischl. Both the forms and subject matter of their work subtly echo his. The German artist Norbert Tadeusz quotes Bacon more explicitly—similar color references can be found in the world of his pictures, as well as Muybridge studies, animal carcasses, and raw meat.

Love is the Devil

In 1998, the BBC produced a film of Bacon's life directed by John Maybury. Called *Love is the Devil: Study for a Portrait of Francis Bacon*, it is based on the biography published by Daniel Farson in 1994 and boasts stars such as Derek Jacobi (as Francis Bacon), Daniel Craig (as George Dyer) and Tilda Swinton (as Muriel Belcher).

Adam Low created a detailed documentary on the painter in *Bacon's Arena*. Archive material and interviews with subjects including John Edwards and George Dyer's brother provide fascinating insights into Bacon's life and work.

Like a door into another world: the insignificant staircase
doesn't give a sense of the chaotic abundance in Bacon's studio.

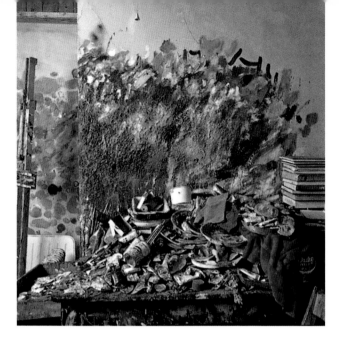

Bacon's atlas of color on the wall
of the studio at 7 Reece Mews.

7 Reece Mews Reloaded

Six years after Bacon's death, the Dublin City Gallery, The Hugh Lane, attempted an unprecedented feat: his 7 Reece Mews studio was to be scientifically recorded, and then, transported to the Irish museum, entirely reconstructed there.

Traces of Creativity

This unusual archeological project got under way in the summer of 1998. A team of researchers and restorers began the task of measuring and documenting every last detail of Bacon's studio. For over 30 years, Bacon's art was created in this 258 square feet (24 square meters) of space. The studio had been left undisturbed since the artist's death—a last, unfinished work is still in position on the easel. As always, the place is filled with his spirit and with traces of the creative struggles that went on here. The restricted space, however, prevents the studio from being turned into a public museum.

> **"I believe in deeply ordered chaos."**
>
> **Francis Bacon**

Like the studio walls, the door also served as a palette for Bacon's paintings.

Homecoming

In order to preserve his friend's studio, Bacon's heir John Edwards decided to make an unusual donation to the museum. The studio, or rather its contents, become the property of Dublin City Gallery, The Hugh Lane. The museum staff, headed by director Barbara Dawson, took on the challenge of moving Bacon's domain and recreating it in Dublin—not only in every factual detail, but with its atmosphere intact. Edwards had his reasons for choosing their museum—Bacon was born in the Irish capital. This makes transferring his studio there a kind of homecoming. According to Edwards, this operation "would have made him [Bacon] roar with laughter."

Inventory

Before the difficult transfer began, Edwards allowed the photographer Perry Ogden access to Bacon's former rooms. Ogden's vivid photographs, which he published in 2001 in a small book, *7 Reece Mews*, record both the chaotic studio and the modest living space. The pictures are presented without a commentary and with only a short, highly personal introduction by Edwards. Being presented like this and allowed to speak for themselves heightens the photos' very special atmosphere. Once this poetic "farewell" was complete, the museum team got to work. First, plans were made that painstakingly recorded the position of furniture and objects in the studio. Removal and transportation followed. In Dublin, the technicians began to investigate every object—no matter how insignificant it appeared at

The studio at 7 Reece Mews is now
a permanent installation in the
Dublin City Gallery, The Hugh Lane.

first sight—and recorded it in a databank. By the
end, this digital catalogue had over 7,000 entries,
from the almost opaque, circular mirror on the stu-
dio wall, designed by Bacon himself in the 1930s, to
individual brushes and pots of pigment. It is not
only the first of its kind, but an essential archive for
anyone researching Bacon. Only after this "invento-
ry" had been made was the studio rebuilt, piece by
piece, based on the photographs and layout plans.

Order in Chaos

This detailed investigation also revealed that al-
though the studio looks disordered at first glance it
does have a kind of order. Bacon kept one area for
painting and one area as the main store for drafts
of all kinds, with materials being kept in the cor-
ners. Unfinished and destroyed works have their
own place. There are one hundred works in total
with which Bacon was unsatisfied, but which he
never actually threw out.

The Studio as a Work of Art

The many traces of paint on the walls and the door
give the room a special character. Bacon never
used a palette; instead, he mixed the colors on any-
thing he came across—pieces of cardboard, plates,
bowls; there is even a paint-smeared baking tray.
The wall was also pressed into service as a palette,
used to match color tones and as a reference for
future works. Preserving this color atlas—Bacon
once said these were his "only abstract works"—
turned out to be the hardest part of the whole en-
deavor, but not impossible. Today, the paint-en-
crusted plaster is still part of the studio, now a per-
manent installation in the Hugh Lane Gallery, giv-
ing visitors the unique opportunity to experience a
"three-dimensional" manifestation of Bacon's inner
world of images.

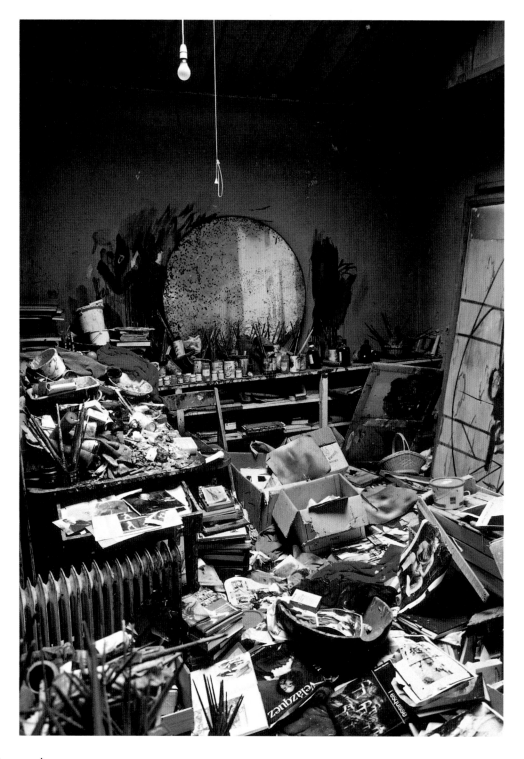

A unique universe The photographer Perry Ogden documented the chaos in Bacon's studio before The Hugh Lane team removed everything layer by layer, catalogued it, and then rebuilt it in the Irish capital, Bacon's place of birth.

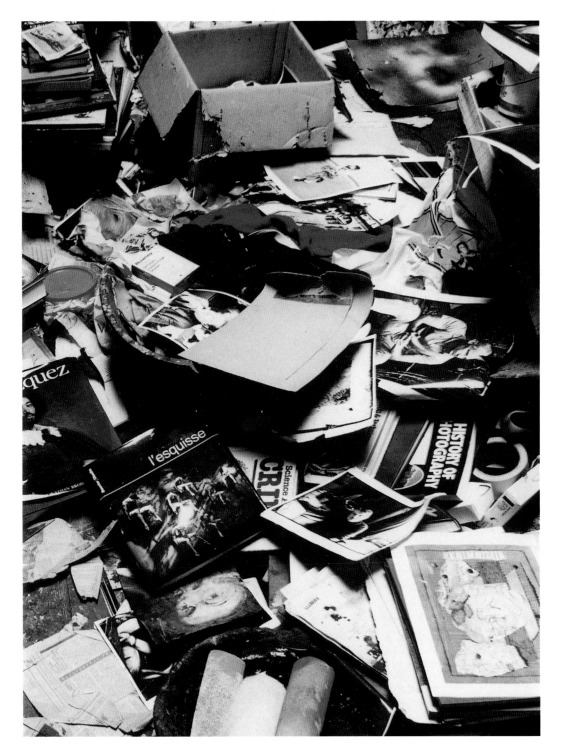

Fertile chaos In an interview, Bacon explained his belief that it was the task of pictures to create order. Thanks to its donation to the Dublin City Gallery, this anarchic collection of inspirations, drafts and working materials was preserved for posterity.

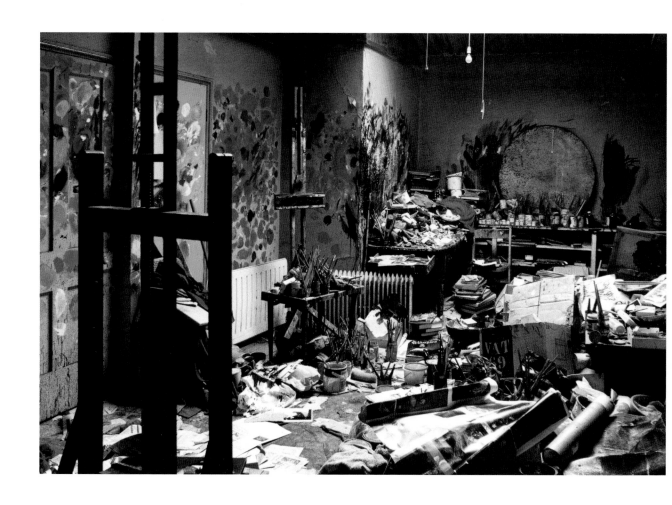

Walls as colored maps Bacon designed a mirror in the 30s that acted as an important reference point in his studio. The flecks of color around this mirror are evidence to how the artist used the walls as his palette.

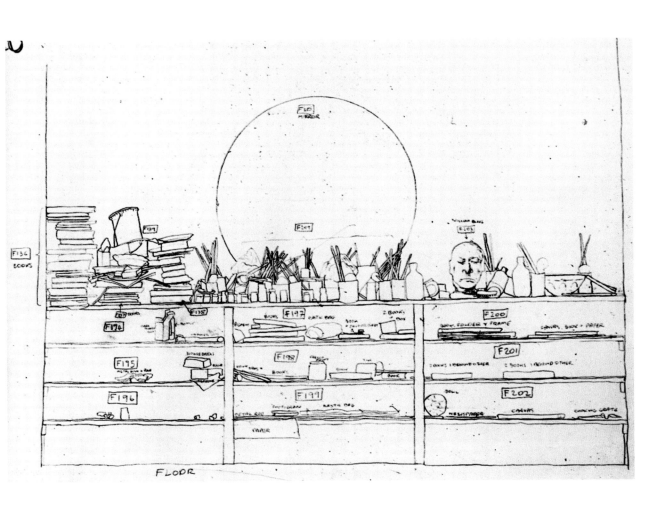

Measurements Museum technicians painstakingly recorded all the objects in the studio in layout plans. After being recorded in a digital archive, the chaotic order in Bacon's studio was recreated in minute detail—but in a museum context.

Picture list

Cover:

Front cover: Francis Bacon, *Study for Portrait of Lucian Freud (Sideways) August 1971*, 1971, oil on canvas, 198 x 147.5 cm, private collection.

Back cover: Francis Bacon, *Self-Portrait*, 1969, oil on canvas, 35.5 x 30.5 cm, private collection.

Outside front flap: Francis Bacon in his Studio, 1960. Photographer: Douglas Glass.

Inside front flap: top, l. to r.: "Black Friday" on the New York Stock Exchange, 1929; Atomic bombs over Hiroshima; Martin Luther King; Pablo Picasso;

bottom, l. to r.: Francis Bacon as a young man; Roy de Maistre; Erica Brausen; David Sylvester; door to Francis Bacon's studio in 7 Reece Mews;

Inside back flap: l. to r.: Francis Bacon, *Figure in a Landscape*, 1945, oil on canvas, 145 x 128 cm, Tate Gallery, London; Francis Bacon, *Study for a Portrait of P.L., no. 2*, 1957, oil on canvas, 151.8 cm x 110.5 cm, Robert and Lisa Sainsbury Collection, Sainsbury Centre for Visual Arts, Norwich, England; Francis Bacon, *Portrait of George Dyer Staring into a Mirror*, 1967, oil on canvas, 198 x 147.5 cm, private collection; Francis Bacon, *Study for a Portrait of John Edwards*, 1988, oil on canvas, 198 x 147.5 cm, private collection;

Title Page: Francis Bacon, *Self-Portrait*, 1973, oil on canvas, 198 x 147.5 cm, private collection.

Page 5: Francis Bacon 1984. Photographer: John Edwards.

Page 6: Vincent van Gogh, *The Artists on the Road to Tarascon*, 1888, oil on canvas, 44 x 48, destroyed during The Second World War.

Page 7 above: Juan Gris, *Breakfast*, 1915, oil, crayon, and charcoal on canvas, Georges Pompidou Centre, Paris.

Page 7 below: Jackson Pollock with *Alchemy* on the floor, c. 1947. Photographer: Wilfried Zogbaum.

Page 8: Berlin, Potsdamer Platz with the Hotel Fürstenhof, Haus Vaterland and Potsdamer Station, c. 1925.

Page 9: George Grosz, *Pillars of Society*, 1926, oil on canvas, 200 x 108 cm, Neue Nationalgalerie, Berlin.

Page 10: Leon Kossoff. Photographer: Jorge Lewinski.

Page 11: Frank Auerbach. Photographer: Marc Trivier.

Page 12: Frank Auerbach, *Camden Theater in the Rain*, 1977, oil on plate, 121.9 x 137 cm, private collection.

Page 13: Leon Kossoff, *Nude on a Red Bed*, 1972, oil on plate, 121.9 x 182.8 cm, Saatchi collection, London.

Page 15: Francis Bacon, *Self-Portrait*, 1969, oil on canvas, 35.5 x 30.5 cm, private collection.

Page 16: Michel Leiris in his apartment, 1976. Georges Pompidou Centre, Louise and Michel Leiris Foundation, 1984.

Page 17 above: David Sylvester, December 1948. Victoria and Albert Museum, London.

Page 17 below: John Edwards. The Estate of Francis Bacon. Photographer: unknown.

Page 18: Francis Bacon, *Painting*, 1946, oil on canvas, 198 x 132 cm, Museum of Modern Art, New York.

Page 19: Erica Brausen in front of *La Tauromachie* by Germaine Richier, 1953. Photographer: Ida Kar. Hanover Gallery.

Page 20 left: Francis Bacon, *Portrait of Robert Sainsbury*, 1955, oil on canvas, 115 x 99 cm, Robert and Lisa Sainsbury Collection, Sainsbury Centre of Visual Arts, University of East Anglia. Photographer: James Austin.

Page 20 right: Francis Bacon, *Study for the Portrait of Lisa*, 1955, oil on canvas, 61 x 51 cm, Robert und Lisa Sainsbury collection, Sainsbury Centre of Visual Arts, University of East Anglia. Photographer: James Austin.

Page 21: View in the exhibition "Francis Bacon" in the Tate Gallery, London, May 1962.

Page 22: Francis Bacon and Peter Beard, 1975. Photographer: unknown.

Page 23 left: Staircase to the Grand Palais at the morning of the opening exhibition of "Francis Bacon," 26th October, Paris. Photographer: unknown.

Page 23 below: Line in front of the entrance to the exhibition *Francis Bacon*, September 1988, Moscow, Central House of Artists. Photographer: unknown.

Page 24/25: Francis Bacon, *Three Studies for Figures at the Base of a Crucifixion*, oil on canvas, 1944, 95 x 73.5 cm, Tate Gallery, London.

Page 26/27: Francis Bacon, *Three Studies for a Crucifixion*, 1962, oil on canvas, each 198.2 x 144.8 cm, The Salomon R. Guggenheim Museum, New York.

Page 28: Francis Bacon, *Lying Figure in Mirror*, 1971, oil on canvas, 198 x 147.5 cm, Museo de Bellas Artes, Bilbao.

Page 29: Francis Bacon, *Sand Dune*, 1981, oil on canvas, 198 x 147.5 cm, private collection.

Page 31: Francis Bacon, *Landscape*, 1978, oil and pastel on canvas, 199 x 147.5 cm, private collection.

Page 32 left: Portrait of Thomas Stearns Eliot, c. 1935, St. Louis, Missouri.

Page 33 above: Michelangelo Buonarroti, *Backside of a Male Nude*, c. 1504, black cryon, highted white, 194 x 266 cm, Albertina, Vienna.

Page 33 right: Eadward James Muybridge, c. 1901. Photographer: unknown.

Page 33 below: *Animal Locomotion, Animals and Movements, Horses, Gallop, Thoroughbred by Mare, Annie G, Plate 626*, 1887. Photographer: Eadward James Muybridge.

Page 34: Francis Bacon, *Crucifixion*, 1933, oil on canvas, 62 x 48.5 cm, private collection.

Page 35: Francis Bacon in his Studio, 1960. Photographer: Douglas Glass.

Page 36 left: Double page from Herbert Reads Volume *Art Now - An Introduction to the Theory of Modern Painting and Sculpture*, 1933.

Page 36 right: Nicolas Poussin, *The Massacre of Innocents*, 1628–29, oil on canvas, 147 x 171 cm, Musée Condé, Chantilly.

Page 37: The enlarged still of the dying nursemaid from *Panzerkreuzer Potemkin*, 1925. Director: Sergei Eisenstein.

Page 38: Velázquez, *Pope Innocent X*, 1650, oil on canvas, 141 x 119 cm, Galleria Doria Pamphilj, Rome.

Appendix

Page 39: Francis Bacon, *Study after Velázquez's Portrait of Pope Innocent X*, 1953, oil on canvas, 153 x 118 cm, Des Moines, Des Moines Art Center.

Page 40: Francis Bacon, *Head VI*, 1949, oil on canvas, 93.2 x 76.5 cm, Arts Council Collection, Hayward Gallery, London.

Page 41: Francis Bacon, *Study for a Portrait*, 1949, oil on canvas, 147.5 x 131 cm, Museum of Contemporary Art, Chicago.

Page 42: Francis Bacon, *Two Figures*, 1953, oil on canvas, 152.5 x 116.5 cm, private collection.

Page 43: Francis Bacon, *Two Figures in the Grass*, 1954, oil on canvas, 152 x 117 cm, private collection.

Page 44/45: Francis Bacon, *Studies from the Human Body*, 1970, oil on canvas, each 198 x 147.5 cm, private collection.

Page 46: *The Human Figure in Motion*, 1901, 20 x 27.3 cm. Photographer: Eadward James Muybridge. Page taken from black and white motives of wrestling, found in Bacon's studio, Dublin City Gallery The Hugh Lane.

Page 47 left: *Isabel Rawsthorne in a Street in Soho*, 1967, Dublin City Gallery The Hugh Lane. Photographer: John Deakin

Page 47 right: Francis Bacon, *Portrait of Isabel Rawsthorne Standing in a Street in Soho*, 1967, oil on canvas, 198 x 147.5 cm, Neue Nationalgalerie, Berlin.

Page 48: Francis Bacon, 1952. Photographer: John Deakin

Page 49: Reproduction of a crucifixion by the Italian painter Cimabue, 2nd half of 13th century, from Bacon's stock of work models, Dublin City Gallery The Hugh Lane.

Page 50: Chaim Soutine, *The Beef*, 1925, oil on canvas, 166.1 x 114.9 cm, Stedelijk Museum, Amsterdam.

Page 51: Rembrandt van Rijn, *The Carcass of Beef (The Flayed Ox)*, 1655, oil on wood, 94 x 67 cm, Louvre, Paris.

Page 52: Francis Bacon, *Three Studies for Portrait of Isabel Rawsthorne*, 1965, oil on canvas, each 35.5 x 30.5 cm, Robert and Lisa Sainsbury collection, Sainsbury Centre of Visual Arts, University of East Anglia, England. Photographer: James Austin.

Page 53: Francis Bacon, *Self-Portrait*, 1969, oil on canvas, 35.5 x 30.5 cm, private collection.

Page 54/55: Francis Bacon, *Crucifixion*, 1965, oil on canvas, each 198 x 147.5 cm, Bayerische Staatsgemäldesammlungen, Courtesy of Pinakothek der Moderne, Munich.

Page 56: Francis Bacon, *Self-Portrait*, 1973, oil on canvas, 198 x 147.5 cm, private collection.

Page 57: Francis Bacon, *Landscape*, 1978, oil and pastel on canvas, 199 x 147.5 cm, private collection.

Page 58/59: Francis Bacon, *Second Version of a Triptych 1944*, 1988, Acrylic and oil on canvas, each 198 x 147.5 cm, Tate Gallery, London.

Page 61: Study for Self Portrait, 1982, oil on canvas, 198 x 147.5 cm, private collection.

Page 62: Timothy Behrens, Lucian Freud, Francis Bacon, Frank Auerbach and Michael Andrews at *Wheeler's*, 1962, London. Photographer: John Deakin. The Estate of Francis Bacon.

Page 63 above: Francis Bacon in front of Hotel Ritz in Madrid, on his way to Gibraltar and Tanger, 1956. The Estate of Francis Bacon.

Page 63 below: Entrance of Bacons Atelier, 7 Cromwell Place, South Kensington. Photographer: Cathy Cunliffe.

Page 64: Francis Bacon, *Self-Portrait*, 1965, oil on canvas, 198 x 137 cm, private collection.

Page 65: Bacon's Family in Bradford Peverell, from left to right: his sister Ianthe, his younger brother Edward, a French servant, his mother Christina and his father Edward. Victoria and Albert Museum, London.

Page 66 left: Francis Bacon outside "Farmleigh", Abbeyleix, Co Laois, Ireland, c.1924 Victoria and Albert Museum, London.

Page 66 right: The mother of Francis Bacon and his two sisters Winifred and Ianthe. The Estate of Francis Bacon.

Page 67: Francis Bacon in Berlin, c. 1928. The Estate of Francis Bacon.

Page 68 left: Roy de Maistre, *Portrait of Francis Bacon*. Courtesy of Caroline de Maistre Walker.

Page 68 right: Roy de Maistre in his studio, Spencer Street, in the 60s, in the background the painted folding screen by Francis Bacon, Patrick White collection.

Page 69: Michael Andrews, *Colony Room I*, 1962, oil on hardboard, 121.9 x 182.8 cm, The St. John Wilson Trust.

Page 70/71: Francis Bacon, *Three Studies of Muriel Belcher*, 1966, oil on canvas, each 35.5 x 30.5 cm, private collection.

Page 72: Francis Bacon, *Man with Dog*, 1953, oil on canvas, 152 x 117 cm, Albright-Knox Art Gallery, Buffalo, New York.

Page 73: Francis Bacon, *Study for Portrait of Van Gogh III*, 1957, oil on canvas, 198 x 142 cm, Hirshhorn Museum and Sculpture Garden, Smithsonian Institution, Washington D.C.

Page 74/75: Francis Bacon, *Three Studies for a Portrait of Lucian Freud*, 1965, oil on canvas, each 35.5 x 30.5 cm, private collection.

Page 76: Francis Bacon und Ahmed Yacoubi in Tanger, 1956, detected in Bacons studio. The Estate of Francis Bacon.

Page 77: Location shot of Bacons apartment in Reece Mews, London. Photographer: Perry Odgen.

Page 78: Self-Portrait, 1952. Photographer: John Deakin.

Page 79: Francis Bacon in his studio, 1984. Photographer: John Edwards.

Page 80/81: Francis Bacon, *Three Figures in a Room*, 1964, oil on canvas, each 198 x 147 cm, Georges Pompidou Centre, Paris.

Page 82: Francis Bacon, *Portrait of Henrietta Moraes*, 1963, oil on canvas, 165 x 142 cm, private collection.

Page 83: Francis Bacon, *Landscape near Malabata, Tangier*, 1963, oil on canvas, 198 x 145 cm, Ivor Braka Ltd., London.

Page 84/85: Francis Bacon, *Triptych inspired by T.S Eliot's Poem "Sweeney Agonistes,"* 1967, oil on canvas, each 198 x 147,5 cm, Hirshhorn Museum and Sculpture Garden, Smithsonian Institution, Washington D.C.

Page 87: Francis Bacon, *Triptych, August 1972*, 1972, oil on canvas, each 198 x 147.5 cm, Tate Gallery, London.

Page 88: Francis Bacon, *Triptych August 1972* (the second plate), 1972, oil on canvas, 198 x 147.5 cm, Tate Gallery, London.

Page 89 left: Muriel Belcher. Photographer: John Deakin.

Page 89 right: Henrietta Moraes, in the 60s. Photographer: John Deakin.

Page 90: Francis Bacon, *Portait of George Dyer, Riding a Bicycle*, 1966, oil on canvas, 198 x 147.5. Foundation Beyeler, Riehen/Basel.

Page 91: George Dyer and Francis Bacon in Soho, 1966, detected in Bacons studio. The Estate of Francis Bacon. Photographer: John Deakin.

Page 92: Roy de Maistre, *Portrait of Eric Hall*, oil on canvas, 91 x 70 cm, disposition and date unknown.

Page 93: Francis Bacon, *Figure in a Landscape*, 1945, oil on canvas, 145 x 128 cm, Tate Gallery, London.

Page 94: Francis Bacon, *Study for a Portrait of P.L., no. 2*, 1957, oil on canvas, 151.8 cm x 110.5 cm, Robert and Lisa Sainsbury Collection, Sainsbury Centre for Visual Arts, Norwich, England. Photographer: James Austin.

Page 95: Peter Lacy in Ostia. Marlborough International Fine Art.

Page 96: Francis Bacon, *Portrait George of Dyer crouching*, 1966, oil on canvas, 198 x 147.5 cm, private collection.

Page 97: Francis Bacon, *George Dyer staring at a blind cord*, 1966, oil on canvas, 198 x 147.5 cm, collection Maestri.

Page 98: Francis Bacon, *Portrait of George Dyer Staring into a Mirror*, 1967, oil on canvas, 198 x 147.5 cm, private collection.

Page 99: Francis Bacon, *Two Studies for a Portrait of George Dyer*, 1968, oil on canvas, 198 x 147.5 cm, Sara Hildén Art Museum, Tampere.

Page 100/101: Francis Bacon, *Three Studies of the Male Back*, 1970, oil on canvas, each 198 x 147 cm, Kunsthaus Zürich, Zurich.

Page 102: George Dyer in the studio in Reece Mews, *c.* 1964, 30.3 x 30.2 cm, Dublin City Gallery The Hugh Lane. Photographer: John Deakin.

Page 103: Francis Bacon und George Dyer in the Orient Express, 1965. Photographer: John Deakin.

Page 104: Francis Bacon, *Triptych - In Memory of George Dyer*, 1971, oil on canvas, each 198 x 147.5 cm. Foundation Beyeler, Riehen/Basel.

Page 105: Francis Bacon and John Edwards, London Weekend Television.

Page 106/07: Francis Bacon, *Triptych, August 1972*, 1972, oil on canvas, each 198 x 147.5 cm, Tate Gallery, London.

Page 108/9: Francis Bacon, *Triptych, May-June 1973*, 1973, oil on canvas, each 198 x 147. 5 cm, private collection.

Page 110: Francis Bacon, *Study for a Portrait of John Edwards*, 1988, oil on canvas, 198 x 147.5 cm, private collection.

Page 111: Francis Bacon, *Study for a Portrait of John Edwards*, 1988, oil on canvas, 199 x 147.5 cm, Richard Nagy, Dover Street Gallery, London.

Page 113: Francis Bacon in his studio, 1960. Photographer: Douglas Glass.

Page 114: Scene taken from the movie *Last Tango in Paris*, 1972. Director: Bernardo Bertolucci, 1972.

Page 115 above: Norbert Tadeusz, *Yellow studio*, 1985, 300 x 425 cm, private collection.

Page 115 below: Poster of the movie *Love is the Devil*. Director: John Maybury, 1997.

Page 116: The Door in Francis Bacon's Studio in 7 Reece Mews, South Kensington, London, Dublin City Gallery The Hugh Lane. Photographer: Perry Ogden.

Page 117: South-West Corner in Francis Bacon's Studio in the Reece Mews, London, Dublin City Gallery The Hugh Lane. Photographer: John Kellett, 2001.

Page 118: Door from Bacons Atelier, Dublin City Gallery The Hugh Lane. Fotograf: John Kellett, 2001.

Page 119: Photography of the installation of the studio in Hugh Lane, Dublin.

Page 120: View in the studio 7 Reece Mews, Dublin City Gallery The Hugh Lane Photographer: Perry Ogden.

Page 121: View at the bottom of the studio 7 Reece Meews. Photographer: Perry Ogden.

Page 122: View of the studio in 7 Reece Meews, 1998. Photographer: Perry Ogden.

Page 123: Drawing with objects around the the mirror in Bacon's Studio, Dublin City Gallery The Hugh Lane.

Literature

The best guide to Bacon's work was provided by Bacon himself. In the interviews David Sylvester conducted with him, he spoke freely about his work and his sources of inspiration, about art and life. **Interviews with Francis Bacon**, the English edition, was first published in 1982.

Perry Ogden took remarkably beautiful photos of Bacon's studio at 7 Reece Mews after his death. They were published together with a short text by John Edwards in the small book **7 Reece Mews. Francis Bacon's Studio** (original English edition published in 2001).

The book **Francis Bacon's studio** by Margarita Cappock (2005) provides interesting insights into Bacon's choice of subjects and working methods. It was written in connection with the reconstruction of Bacon's studio in the Dublin City Gallery The Hugh Lane and provides a comprehensible overview of the new discoveries arising out of the painstaking inventory of Bacon's materials.

The British journalist Daniel Farson was a long-time associate of Bacon. Bacon himself authorised Farson's biography of him, but insisted that it not be published until after his death. **The Gilded Gutter Life of Francis Bacon**, finally, was published in 1994. The book recounts Bacon's life from a highly personal perspective, providing unusual and surprising insights.

Wieland Schmied makes some interesting connections in his monograph **Francis Bacon**, which appeared in 1996. Michael Peppiatt's book **Francis Bacon: Anatomy of an Enigma** dating from the year 1998 and John Russell's publication **Francis Bacon** (1971) are also worth reading.

The Estate of Francis Bacon is presently working on a **catalogue raisonné**, edited by Martin Harrison. The publication date has still to be announced.

Imprint

The pictures in this book were graciously made available by the museums and collections mentioned, or have been taken from the Publisher's archive with exception of:
© akg-images, Berlin: pp. 8, 32; © Douglas Glass: pp. 35, 113, outside front flap; © Wilfried Zogbaum: p. 7 (below); © Jorge Lewinski: p. 10; © Mark Trivier: p. 11; © Ida Kar: p.19; © John Deakin: p. 78; © Cathy Cunliffe: p. 63 (below); © Perry Odgen: pp. 77, 121, 122; © Dublin City Gallery The Hugh Lane: 119, 123; Norbert Tadeusz, 115 (above); © Condé Nast Publications Ltd.: p. 48

© Prestel Verlag, Munich · Berlin · London · New York 2009
© for the works illustrated by the artists, their heirs or assigns, with the exception of the following:

All paintings by Francis Bacon © The Estate of Francis Bacon. All rights reserved / DACS 2009, except © Tate pp.24-25, 93; © The Estate of Francis Bacon. All rights reserved / DACS 2009, pp. 5, 46, 47, 49, 62, 79, 89 (left and right), 91, 102, 103, 116, 117, 118, 120, 121,122 by VG Bild Kunst, Bonn 2009; John Edwards, George Grosz and Norbert Tadeusz by VG Bild Kunst, Bonn 2009

The publisher has intensely sought to locate all individual artists, and/or their legal successors or representatives. Persons and/or institutions who were possibly not able to be contacted and who claim legal rights to illustrated works in this volume are kindly asked to contact the publishing house.

The Library of Congress Control Number: 2008942976
British Library Cataloguing-in-Publication Data: a catalogue record for this book is available from the British Library. The Deutsche Bibliothek holds a record of this publication in the Deutsche Nationalbibliografie; detailed bibliographical data can be found under: http://dnb.ddb.de

Prestel Verlag
Königinstrasse 9
80539 Munich
Tel. +49 (0) 89 24 29 08-300
Fax +49 (0) 89 24 29 08-335

Prestel Publishing Ltd.
4 Bloomsbury Place
London WC1A 2QA
Tel. +44 (0) 20 7323-5004
Fax +44 (0) 20 7636-8004

Prestel Publishing
900 Broadway. Suite 603
New York, N.Y. 10003
Tel. +1 (212) 995-2720
Fax +1 (212) 995-2733

www.prestel.com

Translated by: Michael Robinson
Project management: Julia Strysio and Reegan Köster
Editor: Chris Murray
Series editorial and design concept by Sybille Engels, engels zahm + partner
Cover, layout: Wolfram Söll
Production: Sebastian Runow
Lithography: ReproLine Mediateam, Munich
Printed and bound by Uhl GmbH & Co KG, Radolfzell

Printed in Germany on acid-free paper

ISBN 978-3-7913-4202-3